M

SO YOU THOUGHT YOU COULDN'T DR

n't

By SANDRA McFALL ANGELO

DISCOVER ART PUBLICATIONS

So You Thought You Couldn't Draw™

Published by: Discover Art with Sandra, Inc., www.SandraAngelo.com
Call Toll Free: 1 (888) 327-9278. Sixth edition.
Emails: info@SandraAngelo.com, BMCV1@aol.com, or
info@DiscoverArtWithSandra.com.

Copyright ©1989, 1994, 1995, 1998, 2000, 2002, 2006 by Sandra Angelo
First printing 1994
Second edition 1995, revised.
Third edition 1998, revised.
Fourth edition 2000, revised.
Fifth edition 2002, revised
Sixth edition 2005, revised

1. Drawing 2. Art 3. Self Help 4. Art Therapy

Library of Congress Catalog Card No. 95-078792

ISBN 1-887823-11-5
UPC Code 6-00255-3115-3-6

Printed in U.S. A. CIP 95-078792

Interior Layout & Design by Ken Cook, Front and Back Cover by Kailyn Myers

Illustrated by:

Sandra Angelo, Tiko Youngdale, and Gré Hann.

Contributing students:

Nita Draut (front cover), Marilee Johnson, Bob Estell, Gordon Kleim, Fred DeGroot, Grace Igasaki, Nancy Kearin, Cheryl McIver, Marion Clute, Barbara McVey, Nathan Davies, Gre Hann, Tiko Youngdale, Guido Da Pipe, Nita Draut, Larry Rello, Jenene Waters, Sandy Skillern, Kathy Napier and Judy Briggs.

Sue Rello devoted countless hours to the revision of the Sixth Edition of this book. Thank you so much Sue! You are a great friend and fabulous organizer. To the reader... this book has FINALLY been left-brain proofed. Enjoy!

Front and Back Cover by:

Kailyn Myers

Interior Design and Layout by:

Ken Cook

Call Toll Free:

1-888-327 9278

www.SandraAngelo.com

Cultivating an Artistic Mindset

Success begins in the mind. Failure starts there too. If you want to excel at drawing, you need to cultivate a way of thinking that will be conducive to right brain activities. Since a majority of my students are left-brain dominant, they have to learn how to access the right brain by understanding the different functions of the left and right hemispheres.

You have a dominant side in your brain. Although you use both sides, like right and left-handedness, you have a prevailing side.

Here is a partial list of the ways that dominance manifests itself:

Right Brain Person	Left Brain Person
Experience oriented	Time Oriented
Makes order out of chaos	Needs thing in sequence
Non-verbal	Verbal
Interpretive	Specific
Visual	Not at all visual
Flexible	Critical
Savors the process	Focused on the goal
Intuitive	Formal Sequential Logic
Nebulous	Exact

Left brained people can generally be described in the following terms. They tend to be very time oriented, are seldom late, and have a keen awareness of time regardless of the activity. A left-brain person stops simply because it's time to quit. Have you ever tried to get a stamp from the Post Office at 4:59? It's not going to happen because that's a very left-brained environment.

Left-brained folks need very specific instructions presented in an orderly sequence. They can be quite critical and very aware of how things could have been improved by what they view as a more 'orderly' approach. They are verbal and very specific. When working with a left-brainer, what you ask for is exactly what you will get. (This is definitely the kind of person you want in charge of your prescription.)

Right brain people have no sense of time. When they are working on a job or having a conversation, they finish it and then move on. While the left-brained person just wants to 'get there on time', the right brain person wants to focus on the process and enjoy the journey.

A left-brained individual could live in a house for 10 years and never notice the pattern of the wallpaper in the bathroom. A right-brained character might be able to go to the store and select paint which matches the wallpaper without even taking a swatch. They remember visual cues.

Cultures can be right and left-brained too. I grew up among the pygmies in the Ituri forest in Africa. They would say, "I'll meet you when the sun is over there." Well, it's over there for quite awhile. This drove the Westerners nuts because they couldn't figure exactly what time to be there and they found themselves waiting, for hours at a time. The United States culture is very time oriented. If you are 3 minutes late, someone might look at you like you burped in public. On the other hand, African pygmies live by experience. Not guided by a clock, they finish what they are doing and then move on.

Ambi-brained

Having learned 6 languages, I've observed that every dialect is missing words. For example, one of the African languages I spoke, Psandi doesn't have a word for cookies because the Azandi tribe doesn't have flour, baking soda, or even ovens. Since we gave cookies as a gift to our friends, we had to coin the word 'cookizi.'

English doesn't have a word for people who have developed both hemispheres of the brain because our culture and our schools generally don't develop or value right-brained activities. Hence, very few people in the USA are cross-trained. To find a word that expresses this phenomena, I coined the word ambi-brained.

I myself became ambi-brained because I was raised in schools that didn't allow right-brained activities, so I was forced to cultivate the left. In that sense, I was like a child who is born left-handed and told, "No you're not", that child becomes ambidextrous. My culture forced me to cultivate my non-dominant side. Unlike most artists, I have a strong, healthy left brain. I even graduated cum laude with an M.B.A. That's pretty rare.

After I was forced to cultivate the left side of my brain, I discovered my natural propensity towards right-brained activities. I found this anomaly fortunate because unlike many people in the arts, I can function well in the left-brained American culture.

Not all countries are left brain dominant. When I was teaching at the U.S. International University, I observed that my Asian students were very ambi-brained. Their culture cultivates both sides of the brain from the time they are very small. Consequently they have the beautiful balance that brings. Sadly schools in the United States frequently cut out all the activities that would develop the right side of the brain, like art, dance, music, drama, writing, etc. Thus those who are gifted in the arts frequently show up as poor

students even though they're really not lacking in intelligence. What they are good at simply isn't offered. Everyone looks foolish if you put them in the wrong arena.

I overheard a conversation recently about college admissions at Ivy League American universities. It seems that Asian students were far outdistancing their counterparts so the Ivy League population was becoming very skewed racially. There was discussion about placing a quota on the admissions of Asian students. How sad that there was no curiosity about why the Asians were outdistancing other students! In my view, the Asians are successful because they are taught to cultivate and use both sides of the brain.

Ok, you left-brainers are pretty fed up with this long explanation and want me to get to the point. "Why do I need to know this anyway?" you are muttering to yourself. Because you need to learn how to shut down your bossy left-brain and slip into what we artists call the 'Zone'.

You can't access your right brain on purpose, any more than you can say, "Ok, I'm going to sleep now." What you can do is set up an atmosphere that is conducive to slipping into the right brain. There are 3 ways to do this:

First, you can turn your drawing and the photo reference upside down so that you can't label what you are drawing with words. This verbal shutdown causes the right brain to take over and interpret what you are seeing in right brain terms: shapes, lines, textures, and values.

The second way to shut off the left brain is to use the grid. This tool breaks the object into a collection of shapes.

Third, you can shut the left brain off completely by only exposing a very small part of your drawing reference, blocking out everything except the very square that you are drawing. To do this, simply use an Exacto® knife to cut a hole in a large Post-It®. Make sure the hole is the same size as the grid square you are working on (Use two Post-It® notes so that you can't see through the paper.) This will shut off the left brain completely, because you can't tell what you are drawing. You will see the object in terms of shapes, lines, textures, and values instead of thinking, 'This is an eye.'

If you use these 3 techniques for shutting down the left brain, over time you will develop the ability to slip into the Zone. You will gain access to your own nirvana. Instead of waiting until Friday to relax, you'll be able to take a mini vacation everyday.

For those of you with severe left brains - engineers, accountants, scientists, computer technicians, and others who use the left hemisphere to make a living, this will be a slow

process. You will constantly fight your critical voice that keeps switching on, like a pop-up menu saying, 'This looks really stupid. I can't draw. My drawing looks ridiculous.' This critical dialog prevents you from slipping into the right brain where you could access your drawing skills.

I once saw a program on TV where the doctor was operating on the left side of the brain. The patient was awake because they needed to test him. He was instructed to read words from a chart and midway through the test, they shut off physical access to the left brain. He stopped mid-sentence. Speech is a function of the left brain so when you don't have access, you can't speak. The same is true for right brain functions. If you are in your left brain, you simply can't draw. You need to learn ways to get yourself out of the left brain so that you can access your drawing skills.

This takes practice and time. The more left-brained you are, the more time it takes. When a muscle hasn't been used, it atrophies. If your right brain has turned to mush, you will find it painful to get it back in shape. Just like any exercise routine that works a lazy muscle, it's painful at first. However, the rewards are immeasurable!

How To Use This Book

To make it easier for you to plan your drawing program, I have divided your workbook into daily assignments. Some students draw fast and some work slow. Don't worry if it takes you two-three days to complete a one-day assignment. Take your time. Enjoy the journey.

In the last decade, thousands of students have used this book and it's companion videos. These absolute amateurs were transformed into accomplished artists in anywhere from 60-90 days. There are two key factors in their success: 1) They had a desire that propelled them and 2) They practiced.

This book is not a magic wand. It will not transform you into an artist unless you practice. But if you do, you will be astonished at the rapid transformation in your skills. In about 2-3 weeks you will see a huge improvement in your work.

Practice Daily

To keep you on track, I have divided this book into 60 days worth of exercises. That leaves 30 days to complete the more difficult assignments in the back of the book. That's not much time to invest in building a skill that will serve you for a lifetime.

Keep in mind that everyone works at a different pace so don't be alarmed if it takes you several days to do one drawing. Some of you may be able to zip through a few drawings in a day. The key here is to practice daily. Habits are formed over time and the benefits will be proportionate to your practice. It's almost like you have a meter on your hand. The longer the meter runs, the better your drawings will be.

This sixth edition is the first one with a time journal. Honestly, I think it's impossible to gauge how long it takes for each assignment because everyone works at a different pace. Don't be discouraged if you aren't keeping up with the schedule I've set in the book. This is kinda like a marathon. Some finish faster than others. The point is not to race, but to learn to draw.

Start by reading the first 42 pages, which describe my magic drawing formulas. Then set aside 45-90 minutes daily to practice the exercises in the book. If you do that, you will most likely finish within 60-90 days. Your completion date will depend on how much time you practice and your style. Those who draw very realistic renderings will progress much slower. Those who use casual Impressionistic strokes will work faster. Don't rush. Finishing the book in 90 days is not your goal. The purpose of this book is to teach you how to draw.

When you get to Chapter Seven, it is permissible to work out of sequence. Those drawings are presented in a loosely structured format, with the easiest subject first, gradu-

ally progressing toward the most difficult. While, it's always good idea to begin with easy objects and move toward the most challenging, by the time you reach this chapter, your skills may be strong enough that it wouldn't hurt to jump around a little. Generally, if you look at a drawing and think it's easy, it probably will be, especially if it's a subject you like.

Some folks are reading learners who can learn to draw by simply reading the book and practicing the exercises. Others are visual learners who need to watch the instructor's hand and see exactly how to shade. If you are having a problem with your shading techniques, you may want to purchase the four companion DVD's or videos that demonstrate this book's lessons. *Drawing Basics* will walk you through the first half of the book and show you how to shade and more. *The Easy Way to Draw Landscapes, Flowers and Water* and *The Easy Way To Draw Animals* will demonstrate various drawings in this book. The DVD or video, *7 Common Drawing Mistakes and How to Correct Them*, illustrates the mistakes beginners encounter most frequently as well as the ways to correct them. (See order form in the back of the book.)

If you choose to use the DVD's or videos, be sure to play them over and over again until you fully grasp the shading techniques. Some students have found they have to repeat the lesson several times, drawing along with the instructor, watching the demonstrations again and again before it finally sinks in.

Many folks ask me, 'How long will it take me to learn to draw?' My answer is, 'How many hours per day are you planning to practice?' There is no magic number of days for this process but as a general rule, students who draw for 45-90 minutes per day, usually finish the book in 60-90 days.

For those of you who are on a busy schedule, you can always find at least 45 minutes each day to relax. If you have more than 45 minutes to devote to drawing, that's great. As you begin to improve, drawing will become a retreat where you can enjoy quiet serenity. You won't believe how much fun it is to draw. So turn the pages and let's get started!

Contents

This book is dedicated to the memory of Virginia and Ernest McFall, whose amazing lives taught me by example that there wasn't anything I couldn't do if I had faith.

Introduction

||

Transform your skills from amateur to artist in a few easy lessons ...

Didn't you just hate that kid who was over in the corner drawing super sonic jets when your airplane looked like a goose egg with webbed feet? Or that little girl with the blonde braids who drew horses from the Winner's Circle when your horse looked like a mutant rat on stilts?

Well, if your art never made it to the bulletin board at school and not even to your own mother's refrigerator, here's your chance to avenge yourself and clear your besmirched reputation. Forget losing 30 pounds, tummy tucks, hair implants, or face lifts. After completing the lessons in this book, you will be able to draw a perfect mask to wear to the upcoming high school reunion! You'll show them! No more irreverent snickers or giggles for you.

Now that I've promised you the ability to draw the perfect body, I really do need to insert a disclaimer. This foray into the world of art will not be unlike your first date. You will feel awkward at first, you will spill things, mess things up, you'll feel like a fool at times and wonder when it's going to be over. But like any good friendship, the more time you spend at it, the better it gets.

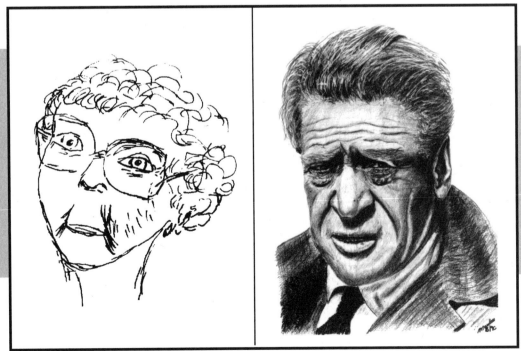

Fig. 1 — These two drawings by Marilee Johnson were seven weeks apart.

What makes you think I can do this?

You've always wanted to draw but you thought you had to be born with talent. I have fabulous news. It's not true! After working with thousands of people who can't draw a straight line, I have developed a sure fire four step method (described on page 43) that will take you from drawing like an amateur to drawing like an artist in a few easy lessons.

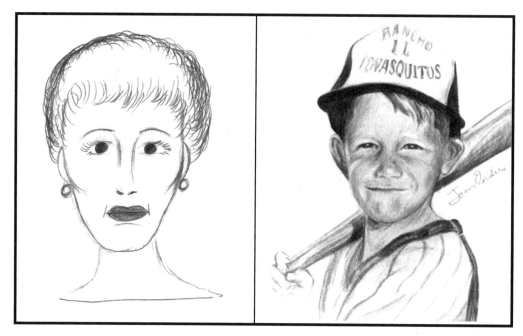

Figure 2— In eight weeks Joan Storms went from drawing with weak skills to rendering this superb drawing of her little grandson.

One of the biggest frustrations for rank beginners like yourself, has been the lack of simple books; art books which assume you know NOTHING. Instead of starting you in first grade, many skip straight to the tough stuff. At last, there is a book written just for you! I'll tell you everything! Which side of the paper to use, which end of the pencil to sharpen, which eraser is best for which pencil, etc. I assume nothing. If you are already past this stage, simply exclaim, 'Pshaw, I know that!' and move on.

This is the first art book designed for people who have no natural talent. It contains lots of information and data that I have gathered from many years of research while teaching people who showed up for class with no more than a desire to get revenge on that Esmerelda Fishback who walked away with all those art awards. I listened to these rank beginners as they watched me draw, and when they said things like,' Look she's pressing harder

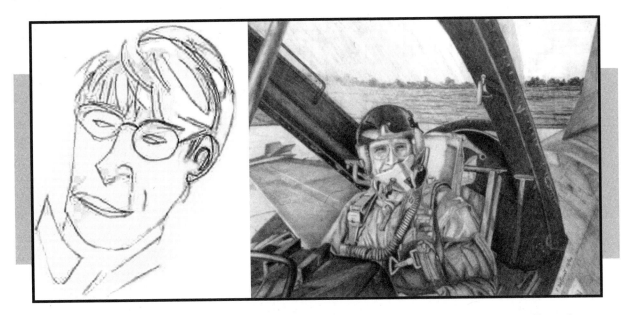

Fig. 3 — In 12 weeks, Fred progressed from drawing like an amateur to drawing complicated, sophisticated art. Even though this drawing was very involved, he found it relaxing because planes are his passion. You see, he was one of the engineers for the F16.

and she just turned her paper around,' the next time I taught , I said, 'Now you press harder and turn your page a little.' (Pretty smart eh?) So now you're the lucky beneficiary of their experience. They taught me what you need to know in order to learn to draw.

Com'on, have you seen me draw...?

More good news! Talent is REALLY not necessary. There are only four ingredients required for drawing success.

First, you must have a burning desire to learn. Whenever one tackles a completely new skill, they often feel intimidated by unfamiliar new terms and the awkwardness of their first steps. A fervent desire to draw, patience, & a willingness to make mistakes will help get you through the times when your flowers turn out looking like mutant potatoes.

Second, you must have fine motor skills and adequate eyesight. Any adult who can write their name has this. (More good news! If you can't draw a straight line, that's great! Most of the lines in art aren't straight. We artists leave straight lines to machines and rulers.)

Third, you must practice. As with any endeavor, practice makes perfect. There is a time meter connected to your hand. The more you draw, the more time you accumulate on the meter. After a certain amount of practice time, you automatically learn to draw.

There is actually a direct cause and effect relationship between practice and successful drawing.

 And the last, and most important ingredient is persistence. The race goes not to the hare but the tortoise. Those who don't give up, succeed. You will be happy to know that in twenty years of teaching, I have never had a single student complete the course without learning to draw, no matter how weak their start. (Look at the before and after drawings in this book!)

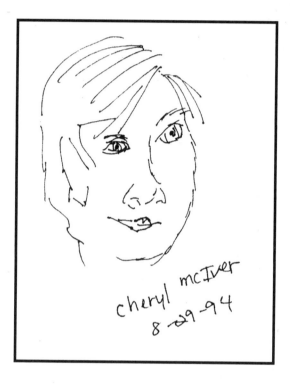 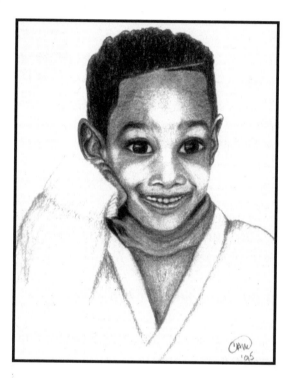

Fig. 4 — Look at the remarkable progress made by Cheryl McIver when she studied the masters' drawing techniques. These drawings were done five weeks apart.

Materials

||

Pencils

All the exercises in this book are done with a graphite drawing pencil. These pencils
are available in varying degrees of hardness. The density of the pencil will determine
how dark or light the mark will be, how smoothly the lead will lay down and how long
your pencil will stay sharp. In the beginning I recommend that you draw strictly with
graphite. It's enough to learn all the drawing techniques without having to figure out how
to use different products. Once you master graphite, you can begin to explore other
drawing media. In my book, *Exploring Colored Pencil*, I teach how to combine a variety
of media. Trying various media is only fun after you know the basics of drawing.

The density chart below shows the varying degrees of hardness commonly available.
Keep in mind that the performance of each pencil will vary greatly from brand to brand.
The pencils I recommend on the order form in the back of this book are specifically
selected to give you the maximum range of values (lights and darks). It really matters what
brand you use. They are not all equal. All the enclosed exercises were done with my brand,
so if you are not getting the same results I do, you may want to switch to my pencils.
Warning: If you use the wrong pencils, you can press down all day and your paper will
get crushed but your values will never get darker. With a good quality pencil, you can get
a very wide range of values. I have a philosophy that says, "Use junk, you get junk. Use
good stuff, you blossom." Don't come whining to me if you use bad pencils.

Drafting Pencils							**Drawing Pencils**						
6 H	5H	4H	3H	2H	F	H	H B*	B	2B	3B	4B	5B	6B

← Harder & Lighter	Softer & Darker →
On this side, the higher the number, the harder the lead will be and the lighter the mark. i.e. 6H will make a lighter mark than a 2H. Because these pencils have a hard lead they will stay sharp longer and give you more detail.The pencils on this side are mainly used for drafting,engineering, architectural rendering, and other work where there is a need for a sharp lead and fine detail.Although some artists use them, most primarily use the pencils on the other side.	As the numbers get higher on this side, the leads get softer and darker. i.e. You will achieve much darker marks with a 6B than a B. These pencils are excellent for soft shading but will dull quickly. Most artists limit themselves mainly to the pencils on this side. On rare occasions where they need light values, like blonde hair, they may venture over to the other side and grab an F.

Figure 5

*The HB is the lead generally used in the common yellow household pencil with that terra cotta eraser. While you can take great phone messages with this, it's pretty lousy for creating deep dark values or soft gradations. If you are a 'hatcher', (meaning you don't mind if your lines show), you might like the HB . If you are a 'graduator', and like soft changes in value, (with no lines showing), you will probably prefer using the B leads.

Because it may drive you to the loony bin if you try to memorize the density charts on page 5, and remember when to use which pencil, I have devised a somewhat idiot proof system for drawing with graphite. I took the three most commonly used densities and labeled them, light, medium and dark. For example, when you want to deface your boss's portrait with blackened teeth, you would use the dark pencil. When you want to draw your Uncle Floyd's silver hair, you would use the light pencil.

Later, in the chapter on shading, you will learn how to create a full range of light and dark values by using only one pencil density. Although I personally don't switch pencils very often, when I want to enhance a dark area I use a 6B. If I want to get a delicate, light stroke I grab an F pencil from the left side of the chart.

I'm not sure how or why the F wandered onto the left side, but somehow it did. (Who knows, maybe Mr. Chartmaker was a bit inebriated that evening, or maybe his wife Myrtle changed it in the middle of the night to sabotage him for not picking up his under-wear, or maybe his first name was Floyd and he wanted to name a density after himself, or maybe... woops, we're digressing.) Anyway, in my opinion, the 'F's' texture is more suited to the B side of the chart, but then I wasn't around when this chart was invented, so there was no one to set them straight.

> **T I P**
>
> Keep in mind, the best way to make lights look really light, is to place strong darks behind them. So, when you are drawing a blonde, you would often use the medium and dark pencil in the shadow areas so as to emphasize the strong light highlights. Even if you just paid $100 to get rid of those dark roots, you must place strong shadows at the roots so as to anchor the hair to the head. Remember, just because a subject is light, doesn't mean you only use light pencils. Even light subjects have medium and dark shadows.
>
> *One More Tip*: In my opinion, (which is usually right), the H pencils don't mix well with the B's unless you have a high quality brand. The texture of the two pencils can be quite different, preventing them from blending. The only time I pick up the lighter leads is when I want to get a really delicate value like the texture of blond or gray hair or a baby's soft skin. If you are using a good brand, the lower number H pencils like H, 2H, 3H and the F will create very light values. With an inferior brand, the H pencils simply indent your paper.

GETTING ACQUAINTED WITH YOUR PENCILS...

Whenever you try out a new tool, it is best to test it and see how it works. Most realists hold their pencil like they would hold a pen. When they draw, they use tight, controlled strokes, drawing with their fingers. This allows them more command over their marks. Artists who do impressionistic, (or abbreviated) renderings like to grasp their pencil like they would a brush. They use arm movements, holding their pencil at a distance, making loose, casual strokes. You might want to try both methods to see which feels most comfortable to you. You may even find that you like to mix it up, drawing the landscape loose, then detailing the goose bumps on a plucked chicken with tight, controlled strokes.

In this book, I have both realistic and impressionistic drawings. My drawings tend to be very exact and delicate. Don't be concerned if your style is not like mine. Look at Figures 8 - 10. We all drew the same subject, yet each person's style was unique and differ-

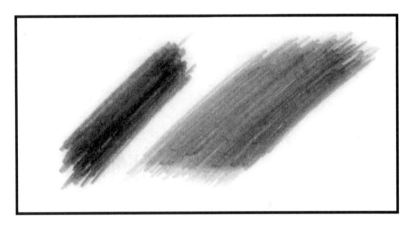

Figure 6: Here is a sample of the texture created by using an H pencil. On the left is a swatch drawn with a 2B. In my view, these two textures don't mix properly.

Figure 7: Here is a swatch drawn with an F pencil. I have blended it into a 2B. In my view, these two pencils' textures look more compatible.

ent. Each of you will have a slightly different style. Just as it is with handwriting, every-one is unique, so, don't be concerned if your drawings don't match the ones in this book exactly.

Figures 8-10: Each of us drew the same subject, but our strokes were unique, making every drawing a different and distinctive style.

Figure 8

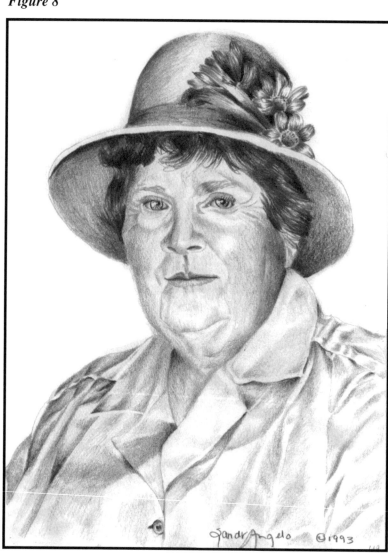

Drawing by Sandra Angelo

Figure 9

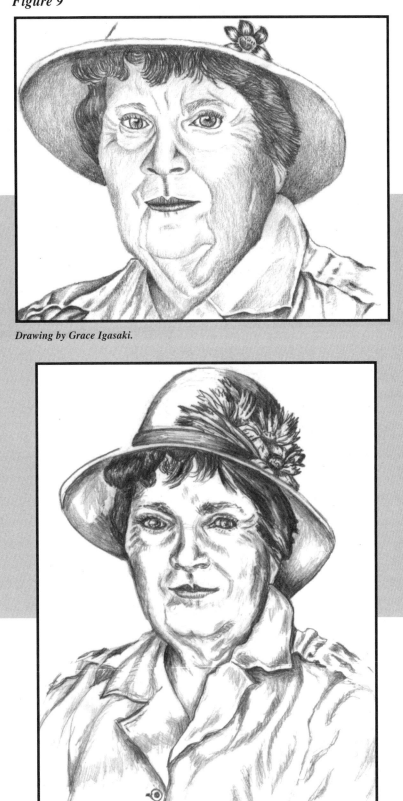

Drawing by Grace Igasaki.

Drawing by Nancy Kearin *Figure 10*

Paper

There are a wide variety of papers available on the market, most of which are bound in sketchpads. The quality varies dramatically and, unlike pencils, quality does not always correlate with price. Some excellent papers are very reasonably priced while some terrible papers are the same price as the good ones. Shopping for a good paper can be quite confusing. Almost every tablet will say its suitable for drawing, even if it isn't, so I made life simple for you.

Good news... your sketch pad is bound into this book. To save you the trouble of guessing which brands would work for these exercises, I bound good quality paper into this book so that you can use it as a workbook and sketch book. If you run out of paper, you can use the order form in the back of this book to send for my special sketch pads. In addition, most of the exercises I recommend require gridded paper so I made it easy for you by drawing the grids right on the practice paper in your book.

Caution! Soap box ahead. (This is where I get up on my podium and lecture about the importance of using good supplies 'cause I don't want to hear your whining when you get bad results using crummy stuff.) I recommend that you do all your exercises right on the paper in this book. Some people, who want to conserve their paper, will try to draw these exercises in other sketch books. This will defeat the whole purpose of why this book was created. I carefully selected the correct paper for you. If you choose your own paper, you might select lousy paper, 'cause you don't know how to choose a paper. Then you'll get bad results.

When you draw with the graphite pencil, your paper needs a 'tooth' or 'bite' to it. This means it needs to have a slightly rough texture so that the graphite will chip off and become deposited into the microscopic grooves of the paper. (To understand this better, remember when you tried to use a pencil to write a mushy poem to your favorite beau on the back of a slick greeting card? The pencil wouldn't stick because the paper was too slick(or maybe your verbage was too mushy). That surface is considered a plate finish and it has no 'tooth'. (Graphite pencils will only adhere to a paper with 'tooth'.)

Things that can go wrong...

You cannot get a full range of values with bad paper and, flimsy paper will pill (like a sweater) when you erase it. If you try to draw on a section you have erased, the graphite won't stick to your paper.

In addition, low quality paper will yellow and slowly deteriorate (Remember what happened last time you left the morning paper on the door step all day. The paper became discol-

ored.) You may want to frame a drawing, or at least save it. If you have paper that is disintegrating, you can't perserve it.

So to save you from your own well meaning frugality with its corresponding failure, I paid big bucks to bind good paper into this book. So use it already!

I have seen so many beginners waste time by using bad paper and cheap pencils. They are not doing the drawings wrong, it's just that they can't get the correct results with bad paper. Nag, nag, nag. I admit it. I have a fetish about using the right supplies. I get tired of the grumbling when people moan to me about their bad results, and it's all because they've used the wrong supplies. So, indulge yourself. Use good materials. (Honestly, the good paper costs exactly the same as the bad stuff. And if you use good quality, you'll save money in the long run 'cause you won't need nearly as much Maalox®.) Okay, okay, I'm climbing down off my soap box now.

ACCESSORIES

Dust Brush
Because graphite can get messy, you will need to purchase a dust brush to rid your paper of graphite residue and eraser crumbs. I use a small, portable goat hair brush because goat hair doesn't leave a residue of graphite on my paper. (I clean my goat hair brush every year or so, hand-washing it in the sink in Woolite®). It's the perfect size and is nice and soft. (I prefer natural hair brushes over synthetic because they are gentle on the paper.)

If you can't find a goat hair brush, you can buy one using the form in the back of the book. Or you can visit Old Mac Donald and borrow one of his trained goats who will swish his tail over your paper on command. (Be careful to use the correct end of the goat. If the goat's head faces your paper, he will eat it, unless it's crummy paper; in which case, you'll wish he would eat it.)

Erasers
An inexpensive art gum eraser will work well to rid your paper of most mistakes. Although this eraser will crumble and smudge the graphite a little, it is the best at lifting large errors.

If you make a section a little too dark, you can gently lighten the area by pressing a

To keep your drawing free of smudges, use a piece of clean paper underneath your drawing hand. This will prevent your hand from picking up graphite and dragging it across your paper. I find that an 8x10 glossy photo with the shiny side down is the most effective shield because the slick paper will not absorb graphite.

kneaded eraser against that object. The kneaded eraser will stick to the paper and lift the dark values, leaving a gentle, soft gradation behind. (Other erasers leave an abrupt edge when they erase.)

My absolute favorite eraser is the small hand held, battery operated eraser because you can actually draw with it. It glides over the surface of the paper lifting the graphite rather than grinding it into the paper and crushing the tooth. To see how it works, look at Figure 11. I drew some grass and lifted out the highlights with my battery operated eraser. (As an aside, this eraser works well with other drawing media including colored pencils. About the only thing it won't erase is cellulite and wrinkles. Believe me, I've tried.) **Caution**: Beware of cheap battery operated erasers. They work fine till they hit the paper, then they stop. The best brand is on our order form in the back of the book.

There are other erasers out there, like pink erasers, plastic erasers and such but in my view these smudge too much. They skid in the graphite and create a little slurry which is very difficult to remove. Therefore, I limit myself to the erasers described above.

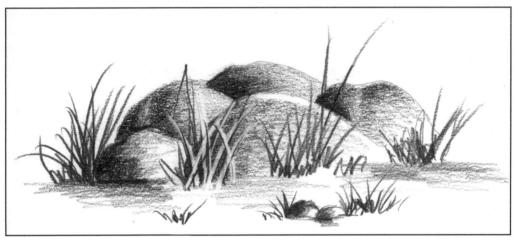

Figure 11

Pencil Cases
Believe it or not, pencils are fragile. The graphite leads inside the wooden casing will break if you drop your pencils on the floor. Then when you sharpen your pencil, the lead will break off into your sharpener. To prevent this, I carry my pencils and erasers around in a neat little case. (All artists with any fashion sense, have a different case for every outfit.)

Fixative
When you are absolutely sure that your drawing is perfect and you never ever want to change it, (i.e. if the Louvre just offered you $30 million for it), you can spray the draw-

Don't be confused by the term workable... that only means that you can draw on top of the fixative. Whatever is underneath the workable fixative is there to stay.

ing with fixative to seal it and prevent it from smudging. I always use workable fixative because I'm never really sure my client will like it that I drew all four of her chins. If I already sprayed the drawing with workable fixative, I can't remove one of the chins, but, I can add graphite pencil on top of workable fixative. So, I could change one of her chins into a turtleneck sweater. (If I had used a matte or glossy fixative, I could not add pencil because the surface would be too slick.)

Caution: Remember that fixative is very toxic. Whenever I spray it, I go outside and lay a weight on each corner of my paper. Holding the can 12-18 inches from the drawing, I lightly coat the paper using horizontal strokes. It is better to give the drawing several light coats, rather than one heavy one. A heavy application will cause the fixative to run.

Because I want to live a long time with my brain intact, I also take precautions so that I won't breathe the fixative. I wear a painter's mask from the hardware store while I am spraying and I close the windows and doors next to that spot. It only takes a few minutes for the fixative to dry but the odor lingers, so I set a timer and leave my drawing outside for 15-20 minutes. (The timer will remind you to retrieve the drawing before the scouts from the Louvre sneak up and steal it.)

Sharpeners

I use three different tools for sharpening. In my studio I use a vertical electric sharpener. For the road, I take along a battery operated sharpener and, to liven up a dull point between sharpening, I keep a piece of sandpaper close by. **Caution**: Avoid the cheap battery operated sharpeners which have simply taken a hand held sharpener and mounted it to a motor. Before you buy a sharpener, remove the casing where the shavings will be stored and look at the blades.

Be careful when you carry your battery operated sharpener around with you. If the casing for the shavings is not well attached, it may come off in your bag and leave a big mess. This problem can often be solved by simply wrapping a large rubber band around the sharpener to secure the casing.

CHAPTER ONE

INSTRUCTIONS
FOR GETTING
STARTED *So where do I begin...?*

A Drawing System For The Artistically Challenged (Notice we didn't say klutz.)

There are many effective ways to learn to draw. Those ways have already been described in other art books. If they had worked for you, you wouldn't be reading this. So, what makes this system different?

Well, believe it or not, I actually started out teaching in high schools, ivy league prep

Fig. 12

Fig. 12 - Look at the dramatic improvement that was made by Nita Draut.

schools and universities. I was teaching a traditional art curriculum to naturally gifted students and my drawing lessons were so effective that I was even selected as one of the nation's top art educators for a Fellowship Award from Rhode Island School of Design. So I thought I could teach anybody. Wrong!

Much to my surprise, when I moved into adult education classes and found a room full of wanna be artists with no real talent, my tried and true, blue ribbon, award winning, traditional drawing lessons didn't cut it. No one understood a thing I said. I discovered that these folks learn in a radically different way. For one thing, they didn't even understand the language of art. Next, they were not inclined to deduce things on their own, they needed to be guided, and shown, step-by-step, with very specific instructions, until they eventually felt comfortable enough to venture forth on their own. So I threw out all of my prized techniques and started from scratch.

In this book I am presenting the results of a proven system that has worked for thousands of people just like you. I learned how to teach these new artists by listening. I listened to them describe the drawing process in their terms and I began to repeat it back. Over a period of years, I perfected this system by watching them and seeing what was effective and what wasn't.

That means there's more good news!

You are not a guinea pig! Many lab rats have paved your way so that you don't have to suffer.

Realize that everything will be presented in a step-by-step format, with a full explanation of the tools you will need and how to use them. While the world will not come to an end if you use the wrong pencil, you will probably get different results with other types of pencils. The whole system is predicated on the assumption that, if these exact methods and tools worked for thousands of others, they will work for you too.

The reason I tell you exactly what to use is because my rank beginners have begged for that format. To those of you who may have one recessive artistic gene, you may feel beginning twinges of rebellion when I tell you exactly what to do. To you, I say, 'If you are getting equal or better results doing it a different way, go for it'. The rest of you really

should follow this book step-by-step in the exact sequence presented, using the same pencils and papers I describe, or else you won't get the dramatic improvement most of my students have experienced. For those who are not naturally artistic, it's usually best to stick to the lesson until you know the rules well enough to break them. (Most good art is made by breaking rules but only by people who learned the rules first.)

Tell your friends emphatically... 'No snickering, unwelcome advice, or disrespect.'

You are embarking on a private journey. No one invites people to listen to them practice the piano, or football, or the violin. Don't let people watch you practice. Your sketch book is private, off limits.

'Why?' you ask.

Everyone is an art critic. Very few people in America, except the very talented, have taken art in school, but that doesn't keep them from being a 'know it all'. They often come up with very thoughtless comments that may sting, wound and discourage you, and all along they were just 'kidding' or 'trying to help'. The rank beginner has a very fragile ego. Most rank beginners don't really believe they can learn to draw in the first place and all it takes is a few of those snide comments to conjure up humiliating memories of art class.

This sketch book is your practice field. If you think someone is going to be critiquing your work, you will be more hesitant to relax and make mistakes. This mind set will keep you out of the creative right side of your brain. So keep this sketch book to yourself. Later, after you've finished this course, you can show everyone your finished pieces... but only show your best work. Believe me, you don't want to hear about the rest!

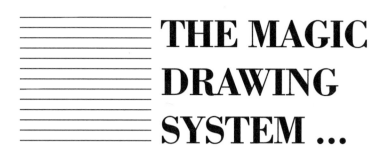

THE MAGIC DRAWING SYSTEM ...

Most traditional art teachers set up a still life or a model in the middle of the room and say, 'Draw'. New artists don't have a clue where to begin. 'Where do I start ... with the eye, the elbow, the ear...? How do I make a three dimensional object on a two dimensional piece of paper? What type of stroke do I use to draw hair? '

To beginners, drawing from live models feels like starting school in 12th grade. Since I believe it's too difficult for a rank beginner to draw objects from real life, I am going to take you back to the easiest form of drawing and present you with a graduated level of difficulty.

• Level One - Copying the Masters

"Stop right there!" you say. "It's cheating to copy." Well, guess what? Everybody's cheating then. Golfers copy Tiger Woods. Pianists copy Van Cliburn. In the Degas wing of the Norton Simon Art Museum, there is a Raphael painting, copied by Degas. If that's the way all the masters did it, guess what? It's legit.

Copying is the easiest form of drawing. It's easy because the drawing is already two dimensional. The artist has already solved the drawing equation, determining the texture of the strokes, the darkness and lightness of the marks, and the direction of the lines. All you have to do is copy.

What do you gain by copying? First, every time you draw, you are developing hand eye coordination. Next, you learn how to create textures, how to shade, how to draw eyes, how to simplify millions of tiny hairs to suggest the style rather than detailing every hair, etc. As with the art of calligraphy, as you copy, you improve your strokes. (Don't be worried about losing your own creative style just because you're copying. Copying good penmanship never made anyone lose their own handwriting. It simply improves your technique.)

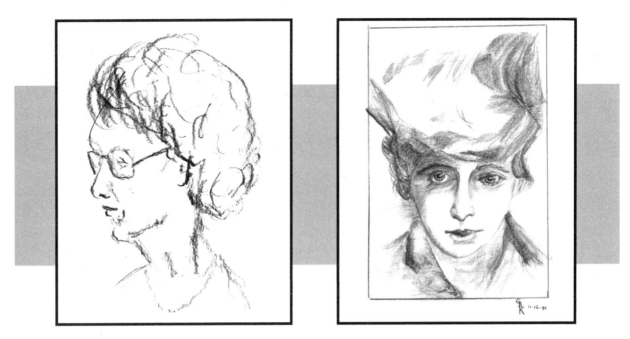

Figure 13: In just five weeks, Gordon Kleim improved his drawing skills dramatically by copying the drawings of the masters.

When do I stop copying?

I recommend that beginners copy the masters until about 80 % of their drawings are turning out well. (Like high jumping, you don't raise the bar till you've been clearing it frequently.) Success breeds success. Stay with the easy things till you get good at them. The confidence you build, will help you gain courage to try the next level. Beginners need a lot of success to keep motivated. If you try things which are too difficult, you will experience a lot of failure. Repeated failure makes most people discouraged and then they give up. Wait till you are succeeding regularly before moving on to Level Two.

• Level Two - Copying From Photographs

Ah ha! Cheating again. Among the myths that surround art, is the belief that it is more noble and pure to draw from real life than to copy from a photo. Why? Because that's the way the masters did it! Do you know why the masters didn't use photos? Because they hadn't been invented!

Since the public expects artists to draw from life, many modern artists try to hide the fact that they use photos. I once read a book where an animal artist was actually claiming he never uses photos, yet his paintings had subjects like a lion leaping through a flying

cloud of dust, chasing a terrified zebra. Right. And I have some great swamp land in Florida.

Photos are fabulous for artists because they trap light, action, a glance, an innuendo, a frisky kid and other stuff that just moves too much. While artists are not slaves to photos, most use a combination of photos and live objects. Photos are a modern tool, so use them. Nobel prize winners use computers, even though the masters used a quill dipped in an ink well. 'The times they are a changin'.

Why is it easy to draw from a photo? Because it is already two dimensional. And, black

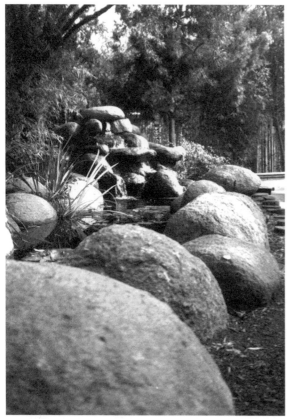

Photo by Sandra Angelo

Fig. 14 & 15 —Drawing from photos is easier than drawing from real life because the object has already been reduced to two dimensions and the values are clear, (meaning it is easy to see the light and dark patterns). Drawing by Gré Hann.

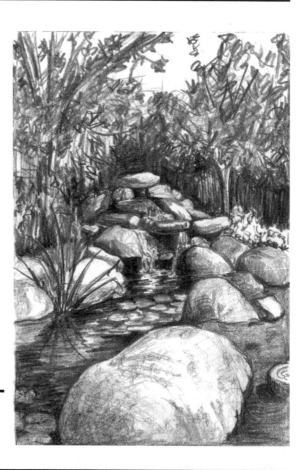

and white photos have already solved the value (that means light and dark) equation, and they can be gridded. (Grids will be explained later on page 44.)

So, once you've graduated from copying masters, begin working from black and white photos. Here, for the first time, you will have to solve the drawing problem. You must decide what kind of strokes to use for the hair, what direction your lines should take when drawing a nose... etc.. I will guide you through this and you will draw on the techniques you learned from copying the masters. After you've reached the 80% success level copying from photos, move on to level three, copying from real life.

• Level Three - Copying from real life.

Now you are ready for the level where most art classes begin, drawing from life. This is hard. Not only do you have to determine the direction of your strokes, but now you must learn how to translate color into black and white, and how to draw a three dimensional object on a two dimensional surface without making it look flat. This will probably be your most difficult transition. However, your practice will have taught you hand eye coordination, how to measure proportions, how to shade and how to create texture. Don't be surprised if it takes a little longer to master this level of drawing.

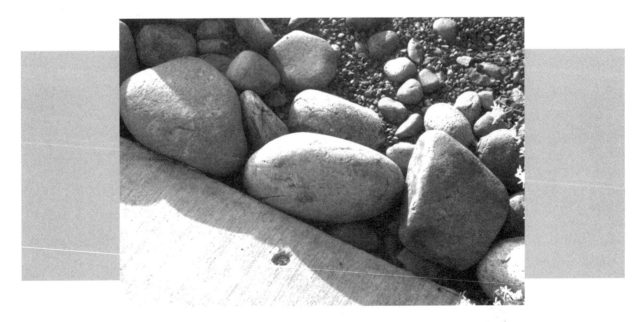

Fig. 16 — When you begin to draw from live objects start out with simple shapes and as your skills improve, increase the level of difficulty.

• Level Four - Composing original, creative art.

A lot of people think that all artists can draw anything out of their head. Surprise! It's not true. In teaching literally thousands of talented, creative, non-talented, and other assorted species, I have discovered that only 5% of talented artists can draw from their imagination. All others use live models, photos or a combination of the two. So if you can't draw out of your head, join the 95% ranks. (Many artists who can draw out of their heads are cartoonists.)

But, even if you can't create imaginary objects and fantastical beasts, after you master your drawing skills and study a variety of media, you will be able to compose original drawings. You will learn how to combine a series of photos with everyday objects, change things around and mix them up until you have an original piece of art which expresses your thoughts and feelings. (You can learn all about that in my next book, *Exploring Colored Pencil*. In that textbook I've written two chapters called *Design Fundamentals and Composing A Drawing*. Those chapters will walk you through the creative process and teach you how to tap your creative skills.

You've either got it or you don't...

To that, I say 'Balderdash!' That's silly. If you picked up a violin, and dragged the bow across the strings and then recoiled from the discordant sound, you would say, 'Naturally I sound bad, I've never learned to play'. But if your first marks with a pencil aren't brilliant, you don't say, 'I haven't developed the skills for expressing myself', you say, 'I can't draw'.

All you really need to be a creative artist is to learn the rules first. As with writing, you learn grammar, syntax, punctuation, spelling and such before you take a creative writing class. You can't write creatively if you don't know the rules. No one would understand you if you couldn't spell and punctuate. So it is with drawing. You must learn the basics before you can express yourself effectively. The lessons in this book will teach you the language of art. This book is like a preschool. Once you've mastered these concepts, you will fit comfortably in any traditional art classroom because you will now understand the language!

You are in for an exhilarating surprise! Learning to draw will liberate your creative mind and provide you with the skills you have wanted so badly, the skill to express yourself visually, whether you want to draw a picture of your boss's face on your dart board, draw yourself with thin thighs and two less chins, or immortalize the world's cutest grand kids for posterity.

So enough hoopla already, let's turn the pages and get started drawing!

Fig. 17 — Practical uses for your new drawing skills... Immortalize your grandkids.

CHAPTER TWO

LEARNING TOOLS

DRAWING WITH A GRID

Artists see the world differently than you do. The key to drawing like an artist is beginning to see the world as they do. They see objects in terms of five key elements: shape, line, value, texture and color. In the following lessons, you will complete exercises which deal with the first four elements. (Color theory is so involved it will require a whole different book.) The lessons in this book will center around the four elements of shape, line, value and texture.

Learn to see shapes.

Artists see objects as a collection of shapes. When a subject is viewed as a series of interlocking jigsaw puzzle pieces, it becomes easier to draw. For example, on page 27, notice that it is much easier to see the shape between the body of the girl and the arm, because it is enclosed. The shape outside the elbow is harder to see because it isn't framed by any lines.

Looking at the background will cause you to draw more accurately. If you look at the subject itself, you tend to glance at it and then look down at your paper for several minutes, drawing from your stored memory about the object rather than drawing what you actually see. When you look at the background space instead, you have to stare at it closely, because the shapes are more nebulous and you can't remember them long enough to draw from memory. Drawing negative space forces you to really pay attention, instead of drawing from memory.

Look at Figure 18. The cement truck is driving away, making this a difficult, foreshortened view. However, when horizontal and vertical lines are placed next to the edges of the truck,

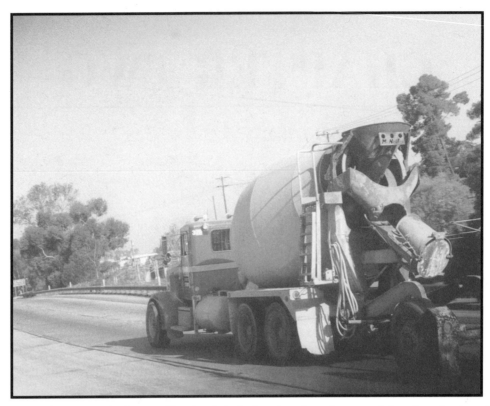

Figure 18 — Guido Da Pipe's Cement Truck might be hard to draw because it is a foreshortened view.

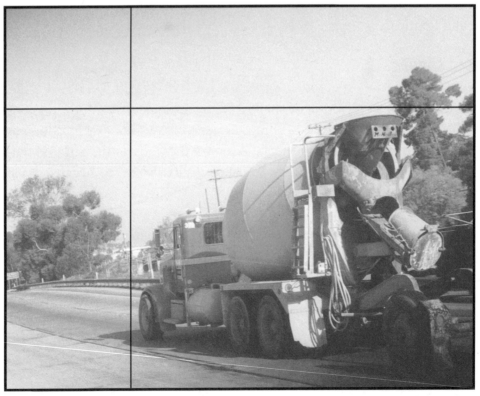

Figure 19 —Here you see a horizontal line above the truck and a vertical line in front of it. When you place a horizontal or vertical line next to the object, it traps the negative space behind the subject, making it easier to draw.

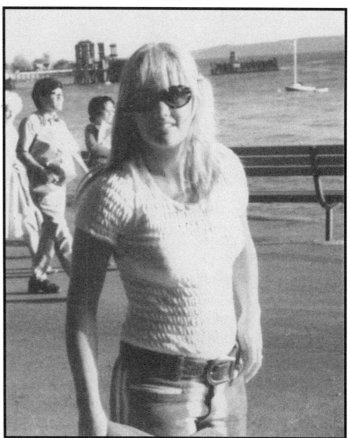

Figure 20 — To draw the arm on the left side of this photo, simply draw the space between the body and the arm and the space outside the elbow. As you can see, it's much harder to visualize the space outside the elbow because it's not enclosed. That's why we use the grid, because lines superimposed onto a photo break the subject up into shapes. Wish I still had THIS shape... I was 21 ... (this shape and my current brain). Yes, that's me, Sandi when I was attending college in Seattle.

(Fig. 19), the lines trap and enclose the negative space. If you simply draw the shapes behind the truck, you will have the position correct. If you learn to draw objects by viewing them as a collection of jigsaw puzzle pieces, you will be more likely to draw accurately.

Using The Grid...

Many artists use a grid of vertical and horizontal lines superimposed over their photo reference in order to see shapes precisely. Remember when we placed a vertical line next to the man's elbow? This helped us to see the shapes more accurately. A grid is simply a collection of vertical and horizontal lines. As we relate each shape to its adjacent vertical or horizontal line, we will find it easier to draw.

Okay here we go again. All of you skeptics are chanting,

'Isn't it cheating to use a grid?'

Time to burst another myth. The masters of old used grids. Look at the two drawings in Figures 21 & 22. One is by Leonardo Da Vinci and one is by Edgar Degas. Even

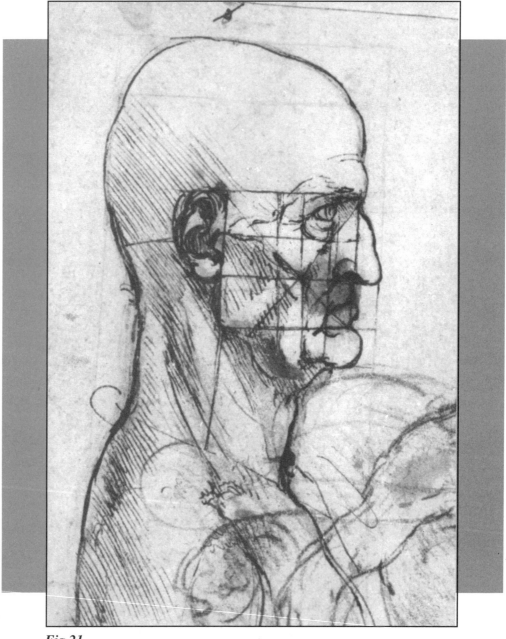

Fig.21

Figs. 21 & 22 — Look at these drawings done by the great masters. Leonardo Da Vinci, and Edgar Degas used a grid. If it's good enough for Ed and Leo, it's good enough for you.

Fig. 22

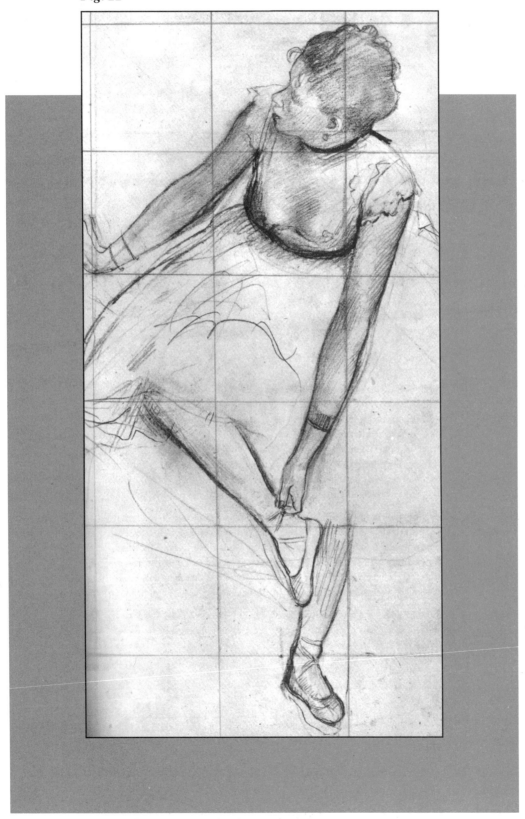

Michelangelo used a grid for the Sistine Chapel. If using a grid was good enough for Ed, Mike, and Leo, shouldn't it be good enough for you?

Three reasons to use a grid...

First, as we stated before, placing a vertical or horizontal line next to our subject will help trap the negative space and allow us to view it more accurately. Second, the grid helps us with proportions. In Figure 23, notice that the man's right eye is lower than the left one. In Figure 24, we have inserted a horizontal line to help us to see that the eyes are at different tangents. Without this line, we would probably look at the man and say to ourselves, 'Self, the man has eyes. Eyes are directly across from each other.' Then we would proceed to draw eyes like the man in Figure 25, wondering all along why he looks so weird. Using grid lines as a reference, we are more likely to place things accurately.

The third use for grids is enlargements. Michelangelo used a grid to enlarge his paint-

Figure 23 — Notice that the eye on the right side of the drawing is higher than the left.

Figure 24 — When we place a horizontal line at eye level, it becomes more evident that the eyes are at different heights.

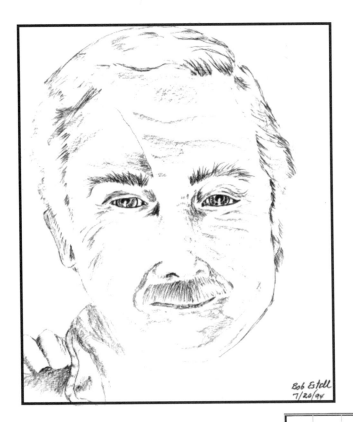

Bob Estell
7/20/94

Figure 25 —If we glanced at the man, and then relied on our stored memory about eyes, we would tend to draw them both at the same level, even though that's not the way they really are. This student, Bob Estell, first drew the man without a grid. He was operating on stored memory that eyes should be at the same level so that is the way he inaccurately drew them.

Figure 26— When he redrew the man using a grid, he realized that the man's head is tilted, making one eye lower than the other. By following the grid, he was able to place the eyes more accurately.

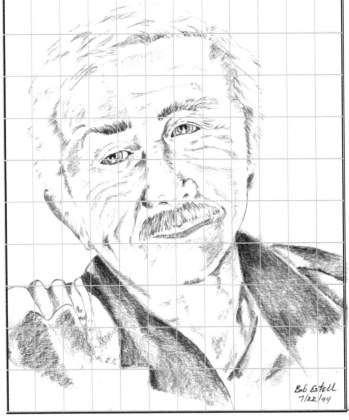

Bob Estell
7/22/94

ing studies for the Sistine Chapel. When you are painting a ceiling, you can't back up to gain perspective. He had to break the subjects into a collection of modules so that he could retain the accuracy of his paintings.

How do I use a grid?

Because all of the practice pages in this book are gridded, you won't need to buy or make a grid kit to complete your lessons. However, after you've finished this book, you may find you need to continue using a grid for awhile. If so, here are the instructions for making a grid.

Option One: Draw lines on your drawing paper with a ruler and a light pencil. Make sure the boxes are always square. Rectangles don't work... (don't ask me why, this is not a geometry class now is it?) With the thin end of a black Identipen draw lines on top of your photo reference and label the grid boxes the same on both your paper and your picture.

Option Two: If you are too lazy to make your own, buy our grid kit listed in the back of the book. It has three acetate sheets with different size grids and grid paper to match. Paper clip the acetate over your photo reference, creating an instant grid. (This also prevents you from having to damage the photo by drawing lines on it.) Lay your grid sheet underneath your sketch paper and paper clip it in place. If you are using our sketch pad, you should be able to see the grid lines through the drawing paper.

How do I know what size grid to use?

Most people can get by with just a few sizes of grids. A one inch grid and a one half inch grid should suffice for most drawings in this book.

The grid size will be determined by the size of the object you are copying. In Figure 27 you can see that a one inch grid is perfect. In Figure 28 a one half inch grid was needed because of the size and complexity of the subject.

Note that you can also use a large grid for the majority of the subject and then subdivide the areas which have more complex details. See Figure 29.

Identifying Tangents

Many students find it useful to place a series of letters across the top and bottom of their grid, and a series of numbers along both sides of the grid. This will help you identify which square you are drawing; i.e. 'B 2' in Figure 27.

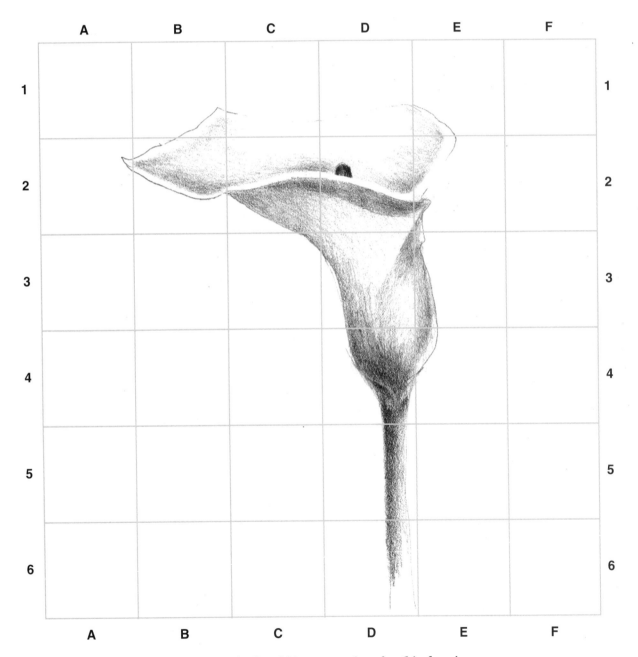

Figure 27—You can see that a one inch grid is appropriate for this drawing.

Drawing by Sandra Angelo

Aaargh! Will I ever outgrow the grid?

Yes. Calm down. Put the sedatives away. You will outgrow this stage. When you were first learning how to ride a bike, you needed training wheels until you learned to keep your balance. A grid is like training wheels. You need vertical and horizontal lines on your page until you begin to see the shapes without them. Eventually you will see objects as a collection of shapes. At that point, you will know you've outgrown the grid.

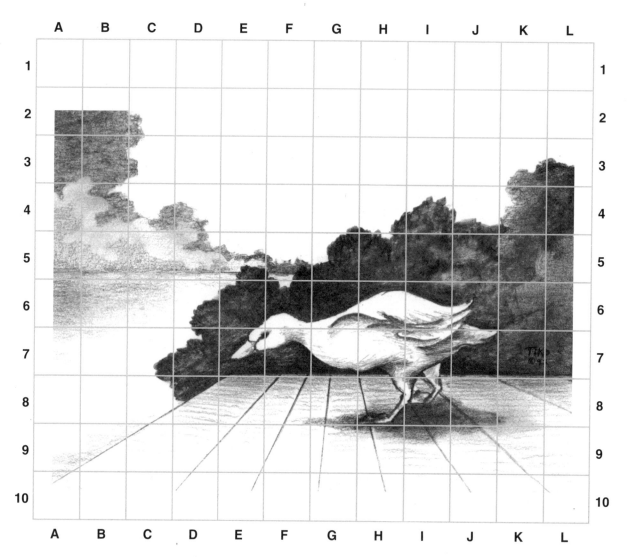

Figure 28 Because of the complexity of the details, a smaller 1/2 inch grid was used over this photo. Drawing by Tiko Youngdale.

However, you will still revert to using an occasional vertical or horizontal line here and there when you are trying to conquer problem areas. That's why Leonardo Da Vinci slapped a grid on the nose. (See Figure 21 on page 28) The face was a piece of cake but that snout was a real bear. The grid helped him resolve the problem.

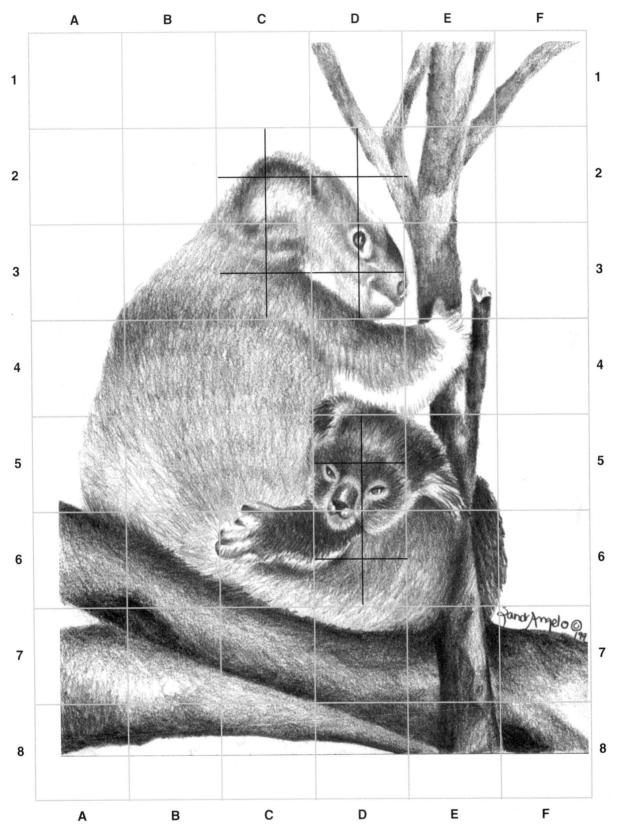

*Figure 29— In some cases, you may use a larger grid for the majority of the photo and then subdivide
the areas which have more complex details.*

NEGATIVE SPACE DRAWING

CHAPTER THREE

SEEING
SHAPES

You will be surprised at how much easier it is to draw things accurately when you begin by drawing just the silhouette while looking at the negative space behind the object. Because our brain stores preconceived notions about objects, we tend to rely on our memory about how these objects should look rather than paying close attention to the angle or perspective in front of us. For example, our brain stores the eye as an oval with a circle in the middle like Figure 30. Look at the eyes in Figure 31 and 32. You can't see the full circle can you? Notice that the three shapes in the eye in Figure 31 are very different than the three shapes in Figure 32. If you drew these eyes by looking at shapes, instead of drawing what you remember about eyes, you would draw more accurately.

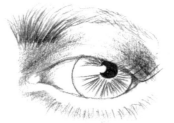

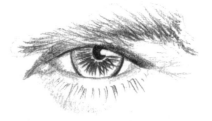

Figure 30—This is the way we think of an eye; an oval shape with a full circle in the middle. If you look at the eyes in Figure 31 and 32, you will see that you cannot see the full circle of the iris. Looking at the eye as a collection of shapes will help you see it more accurately.

Figure 31—Look at the three shapes contained within this eye. The white of the eye on the left is so much bigger than the white space on the right. If you drew these two white shapes and the iris, you would have an accurate eye.

Figure 32—Notice how different the white shapes are in this eye when compared to the shapes in Figure 30.

Drawing negative space is especially helpful when we are trying to draw objects which are foreshortened. Foreshortening means that an object is pointing straight at us. Look at the rhino in Figure 33. His body is coming straight at us. His head, which is in profile, would be easy to draw, but the rump, which is foreshortened, is tough. If we focused on his body while drawing, we would have a terrible time drawing him accurately. However, if we concentrate on the shapes around him (the negative space), as we did in Figure 34, we would be much more inclined towards accuracy.

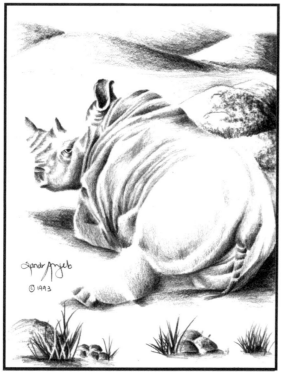

Fig. 33

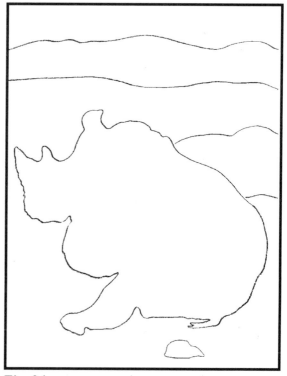

Fig. 34

Instructions For Exercises

We learn to draw the Old Fashioned Way, *we practice*.

Here's a list of general instructions for all the exercises in this book.

One: In Chapters 3 and 4 I've provided a space to try the drawing with the grid and without the grid. Do both drawings. If your drawings are consistently accurate when you don't use the grid, you may not need it. If you don't need the grid, copy the drawings from this book in a sketch pad, (because sketch pages would not be gridded). Most of you however, are rank beginners and will need a grid. You should practice all of your drawings on the gridded paper provided in this book.

Two: We learn to draw the old fashioned way, we practice. If you want to redo any of the drawings, you can use a grid kit and practice the same piece over and over again in your sketchbook, until you are satisfied with the results. While it is very useful to practice the same piece twice or even three times, it's a good idea to complete most of the drawings in the book before going on to repeat them. Don't expect perfection. You are like a first grader ... very new at this. As you continue practicing, your skills will improve automatically.

It's not a good idea to do a lot of erasing. Just draw each subject to the best of your ability and turn the page and draw the next one. You'll be very surprised that some of your drawings will turn out well and others may be a tad worse. You'll find that when you are drawing a subject that you like, you will draw it well, even if it's difficult. Consequently, it's a good idea to start with drawings that look easy and fun. Once you meet with success, you'll have the courage to tackle more difficult subjects.

Three: The tortoise and the hare... remember who won? Take your time with the exercises. Don't compare yourself to others. There is no correlation between speed and talent. New artists who will end up becoming Impressionists generally work faster and those who will be Realists generally work slower. Work at your own speed and don't be pressured to keep up with others. It's better to take your time and make sure you master each concept before moving on.

Four. What does chocolate ice cream have to do with this?

You need to keep a visual record of your progress so that you can see how you are improving. Your drawing will improve very slowly, but just like gaining weight, you will not notice gradual changes. I have this on good authority because I've done the research. I ate just one bowl of Godiva Belgian Dark Chocolate ice cream every day for three months. I really couldn't see the difference until I looked back at a picture of myself in the beginning stages of my research. My figure had definitely changed. Your work will

change too, but the improvement will be very gradual. If you keep each drawing, you will be able to see your progress. Looking back at your early drawings will encourage you.

So, when you make a mistake, try to resist the urge to rip, slash or tear your drawing out of your book and feed it to your ravenous paper shredder. I know it will be difficult, but, if you exercise some restraint, you will be gratified by a visual version of your progress. For example, by the time you get to Chapter Six, you may not feel like you have made any improvement, yet when you look back at the drawings in lesson one and two, you will be amazed at your progress.

In addition, you will often learn a lot from reviewing your first drawings. As you progress, looking back at your old drawings will help you see the importance of using the new principles you have just learned.

Five: As a general rule, it is easier for beginners if the drawing process is broken down into simple steps like the drawings in Figure 35 on page 41. Many beginners find it useful to follow a four step process.

First, begin each drawing by putting in the negative space. Then, inside the same negative space, do a line drawing, which will serve as road map for your shapes and shadows. Next, shade the object to establish the light and dark values and finally, on top of this, place the textures or details. In this revised edition, I have provided negative space and line drawings of many of the exercises.

Six: Some people learn by reading and others are visual learners. Reading learners may be able to acquire all the skills they need by simply reading this book and copying what they see. Visual learners will find it helpful to supplement this book with the companion videos. The videos will allow you to watch my hand up close while I draw and see how I make my strokes, how hard I press, when I turn the paper, etc. The three companion videos for this book demonstrate several of the drawings in this book. They are *Drawing Basics, The Easy Way To Draw Animals* and *The Easy Way To Draw Flowers, Water and Landscapes*. (See the back of the book for ordering info.)

Seven: Because most people who buy this book are time conscious, in this edition, I have broken the exercises down into a set of bite-sized lessons. The schedule assumes that you will be practicing anywhere from 45-90 minutes per day. Most folks will complete the entire book within 60-90 days. (Some may take up to 120 days.) As your work improves, you'll find yourself looking forward to this refreshing hour each day. Art has tremendous therapeutic value. You'll be surprised how fast time flies when you are drawing and how refreshed you will feel afterwards.

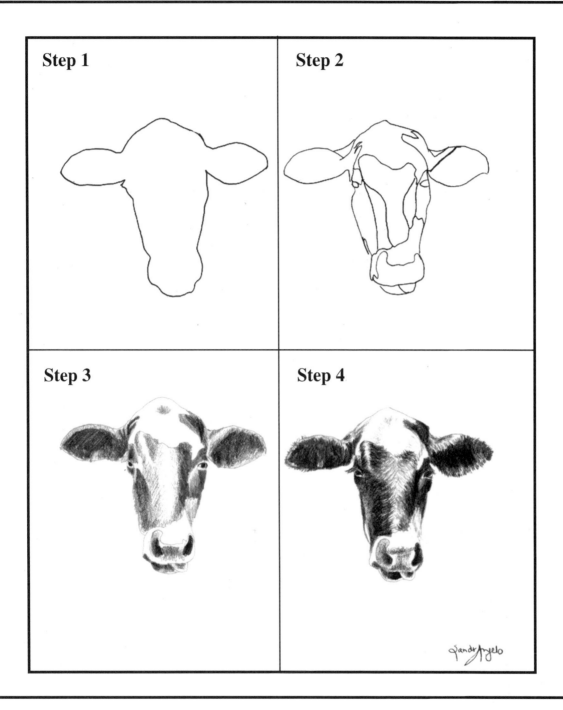

Figure 35 —This progressive drawing of the cow shows the four step process that most beginners use. First the negative space is established, then the contour lines are added, next a study of the light and dark values is completed and the textures are put on last.

Shape Exercises
(Aerobics for artists)

When you draw with a grid, concentrate on one square at a time. As a general rule it is best to start with the section which looks easiest to you. That way, your success will build confidence quickly and you will be ready when you reach the tougher stuff.

If you are having problems with accuracy, think about using a drawing window. To do this:

1) Use an 8 1/2 x 11 sheet of paper (or one side of a manila file folder, because it's sturdier than paper).

2) In the center of the folder, cut a square window that is the same size as your grid square, (i.e. If you are using a one half inch grid, you would cut a one half inch window in the middle of your 8 1/2 x 11 folder.)

3) Place this window over your drawing reference so that you can only see one grid square at a time. This will block out the rest of the drawing and force you to concentrate on only the square you are drawing.

You can peek underneath periodically to make sure you are in the right square, but you should not analyze your drawing or make corrections until you have finished the entire drawing. If you follow this procedure exactly, (without analyzing or correcting while you draw), you will be amazed at your accurate results.

Using a window can seem tedious but it is actually training you to see shapes, lines, and values just like artists see them. Soon you will see them without having to use the window. Like the grid, the window is a training tool.

Shape Exercise

In box 2, draw the negative space of the lamp with the grid. When you are doing this negative space drawing remember to focus on the black space while you draw. You will draw more accurately if you draw the space behind the object rather than the object itself. I have made this negative space black so that it is easier to identify it as a shape.

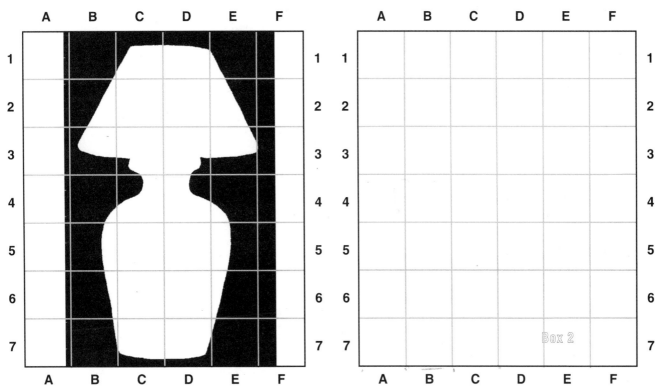

In box four, draw the lamp again, without a grid this time. Did you get more accuracy with or without the grid? If you were more accurate using the grid, you will probably need to use one for most of the lessons. If you did ok without it, try a few more without a grid. See which method gives you the most accurate results.

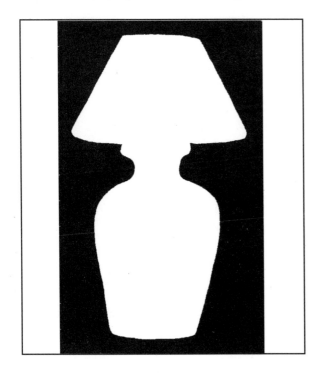

Shape Exercise

In the first box, you will see the object you are to draw. Do a negative space drawing of this object in the second box, using the grid. Then try drawing it without the grid in the box below.

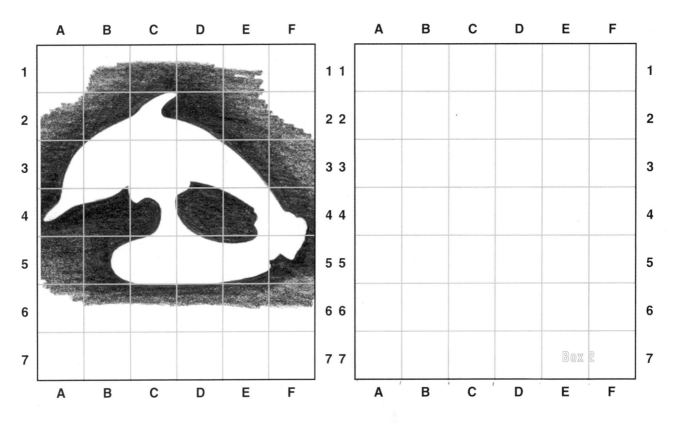

Try again, without the grid.

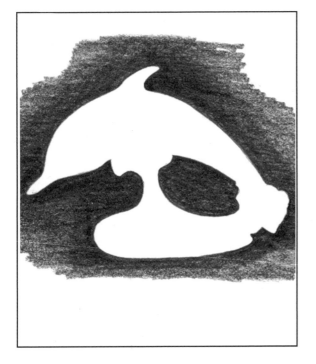

Shape Exercise

In the first box, you will see the object you are to draw. Do a negative space drawing of this object in the second box, using the grid. Then try drawing it without the grid in the box below.

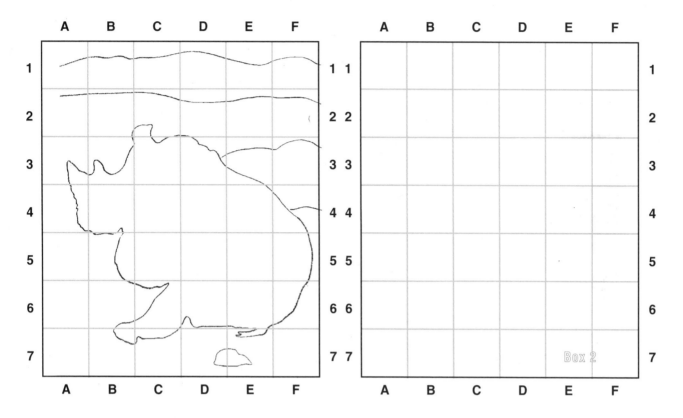

Try again, without the grid.

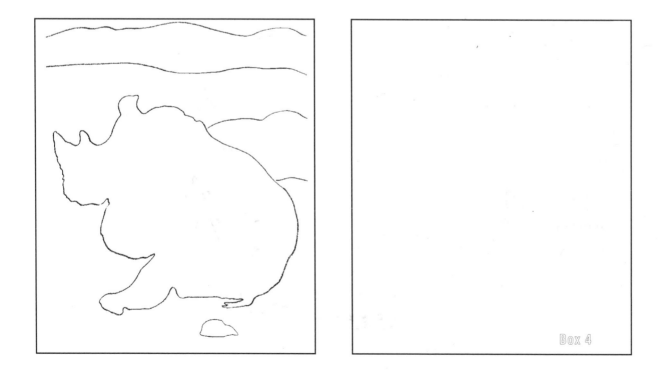

Shape Exercise

In the first box, you will see the object you are to draw. Do a negative space drawing of this object in the second box, using the grid. Then try drawing it without the grid in the box below. (It's okay to use a ruler.)

Try again, without the grid.

Shape Exercise

Now try doing a NEGATIVE space drawing by looking at the final drawing of the elephant. Remember to concentrate on the white space, not on the elephant. Draw only the silhouette.

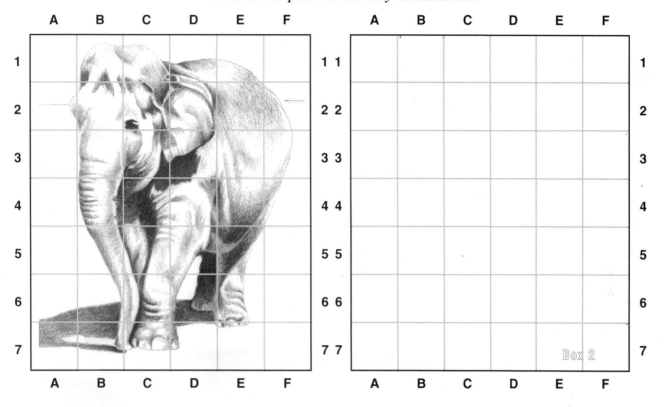

Try again, without the grid this time.

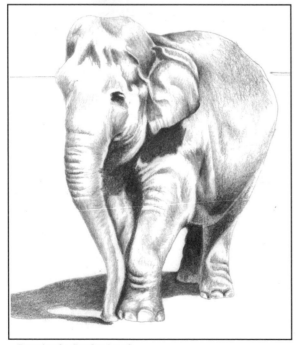

Drawing by Sandra Angelo

CHAPTER FOUR

CONTOUR LINE DRAWING

SEEING
LINES

Most artists begin their drawing by laying down an elaborate map which dictates where they will place their shapes and shadows. Reducing an object to its simple line elements helps the artist solve the proportion and placement problems before shading. These drawings, which show both the interior and exterior lines of an object, are called contour line drawings. If you want to impress your friends, casually refer to your line drawings as a collection of contour line drawings. This sort of conversation makes for great reparteé over cocktails with your boss, a date, or anyone you're trying to amaze.

In Figure 36 you see a negative space drawing of the rabbit. In Figure 37 we filled in the interior contour lines. These lines will later serve as a map for placement of our interior shapes & shadows.

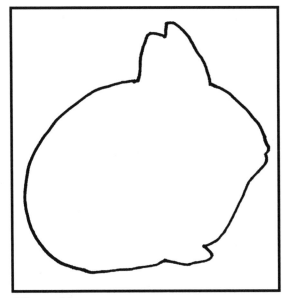

Figure 36

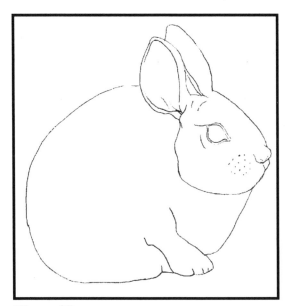

Figure 37

Line Exercises

In the first box, you will see the object you are to draw. Do a negative space drawing of this object in box 2, using the grid. In the same box, fill in the interior contour lines to establish a map for your shapes and shadows. Then try this same drawing without the grid in the box below.

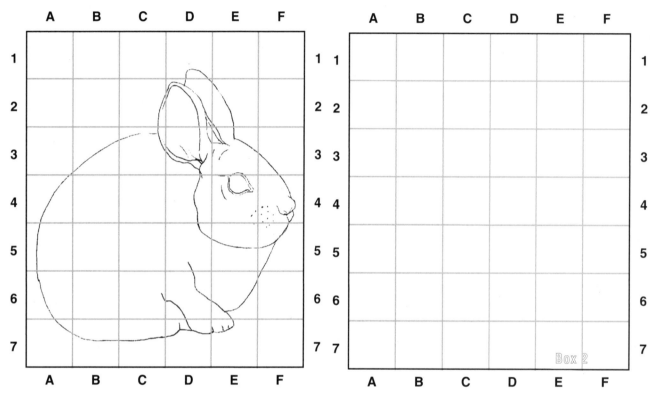

If you want to try the same drawing now without the grid, give it a whirl.

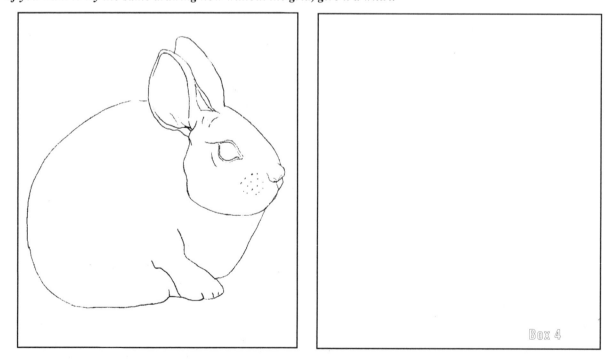

Line Exercise

Copy the contour line drawing.

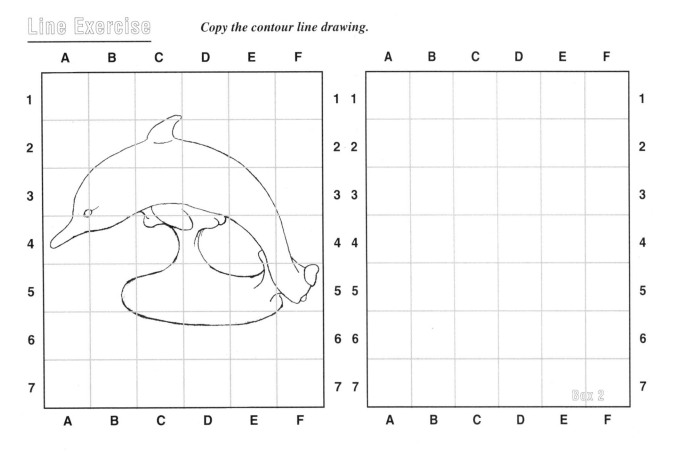

If you want to try the same drawing now without the grid, give it a whirl.

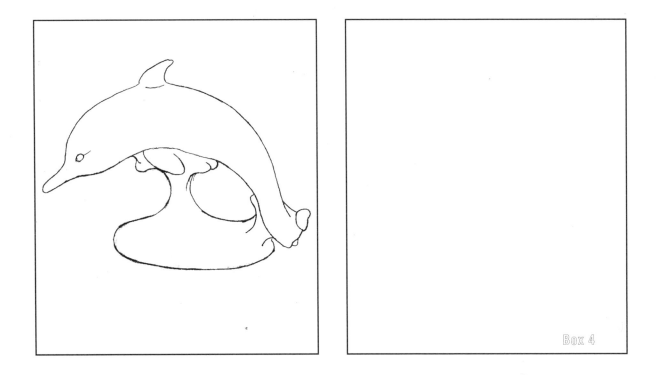

Line Exercise *Copy the contour line drawing.*

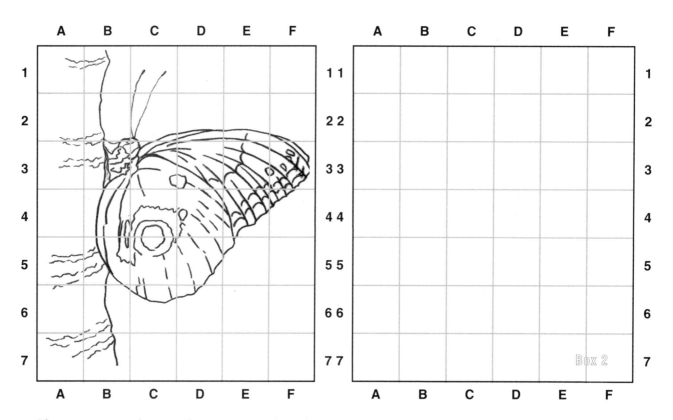

If you want to try the same drawing now without the grid, give it a whirl.

Line Exercise

Copy the contour line drawing.

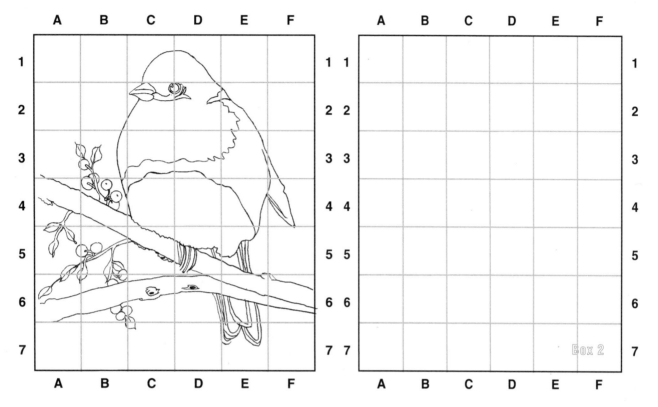

If you want to try the same drawing now without the grid, give it a whirl.

CHAPTER FIVE

VALUE DRAWING

LEARNING TO SHADE

In the art world, shading is referred to as a value study. To show the world how savvy you are, go around referring to shadows as deep values. Look into your loved one's baby blue eyes and say, ' What light values you have, my dear.' (If he responds, 'All the better to see you with, my dear,' beware!)

Learning to see the light and dark values in the objects that you draw is absolutely crucial because drawings and paintings with a full range of values have much more dimension and depth to them. Understanding how to create value will provide the foundation for all your future art endeavors. Or as my old crotchety art teacher, Mr. Dingleberry used to say, 'You need to take a second look at your values, honey.'

What do you mean you want to change my values..?

To avoid a rainbow effect like the one you see in Figure 38, go back over the section where values change and blend the two neighboring values together like the ball in Figure 39.

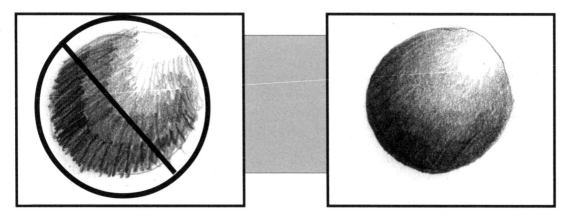

Figure 38 *Figure 39*

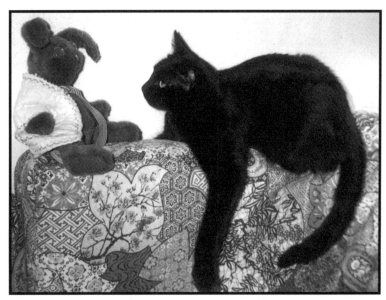

Photo by Sandra Angelo ©1989

Figure 40

When you look at the photograph in Figure 40 you will see that there are many shades of black, white and grey. Using a scale of one to ten, with one being white and ten being solid black, rate each shape and shadow that you see. If you can accurately draw these values the way they appear in the picture, your drawing will have depth and it will look three dimensional. If, like most beginners, you use all medium values, your drawing will look flat like the drawing in Figure 38. Look at how much more dimension there is in the drawing in Figure 39.

It is interesting to note that you will use this same rating system to determine your values even when you switch to color and begin painting with watercolors, acrylics, oils, pastels, colored pencils, and all other art media. That's why it is so crucial for you to learn to see every shape and shadow in terms of its value rating.

Shading Exercises

Are you afraid of the dark...?

Most beginning artists are terrified to draw dark values because they feel dark mistakes are much worse than light ones. As we just said, unless a drawing or painting has a wide range of light and dark values, it will look flat and lifeless. The most common mistake among beginners is the lack of depth in their values.

To learn how to use a pencil to create light and dark values, let's begin by practicing our value scales.

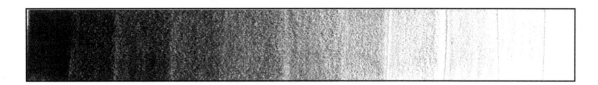

Shading Exercise

Instructions: Using your 3B or medium pencil, create 10 different values in the boxes below. You can copy from the value scale above.

Shading Exercise

Now try the same exercise with your 6B or dark pencil. I have provided several practice boxes so that you can keep trying this exercise until you get exactly 10 different values. You can copy from the value scale above.

TIP

To shade an object with even tones that gradually move from light to dark, use a shading technique called 'gradation'. Gradation simply means to shade without showing your lines. The easiest way to graduate your values is to move your pencil back and forth, blending the adjacent lines so that no texture shows. You can change the lightness or darkness of your value by pressing harder or lighter on your pencil. (When I graduate my values, I don't lift my pencil off the paper at all.)

CREATING DEPTH IN YOUR DRAWING

How do I make it look round?

There are four ways to shade which will create depth in your drawing.

One: If you use a gradual change in value from dark to light, your object will begin to look round. See the ball in Figure 42.

Two: You must have a wide range of values in your shading. Look at the ball in Figure 41. Because there are only a couple values, the ball looks flat. By contrast, the ball in Figure 42 has a wide range of lights and darks, making it look very round.

Figure 41 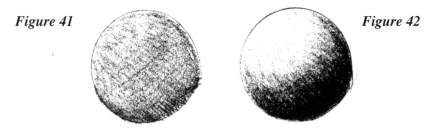 *Figure 42*

Three: Your pencil strokes should always follow the contour of the object. In Figure 43 the pencil strokes go every which way. The ball looks flat. In Figure 44 the strokes follow the contour of the ball. This ball is beginning to look round.

Figure 43 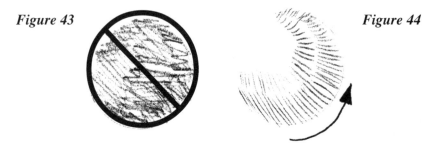 *Figure 44*

Four: If you place dark at both edges and light in the middle, your object will look round like the cylinder in Figure 46. In Figure 45 the cylinder only has one value so it looks flat. (Notice too that the bottom on the cylinder is flat while the top is round. This is the way most beginners draw cylinders. The correct way to draw a cylinder is to make sure the arc of the ellipse at the top of the cylinder is the same as the curvature of the ellipse at the bottom just like the cylinder in Figure 46.)

Figure 45 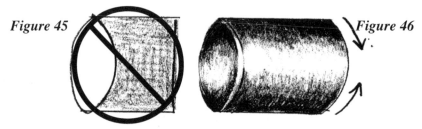 *Figure 46*

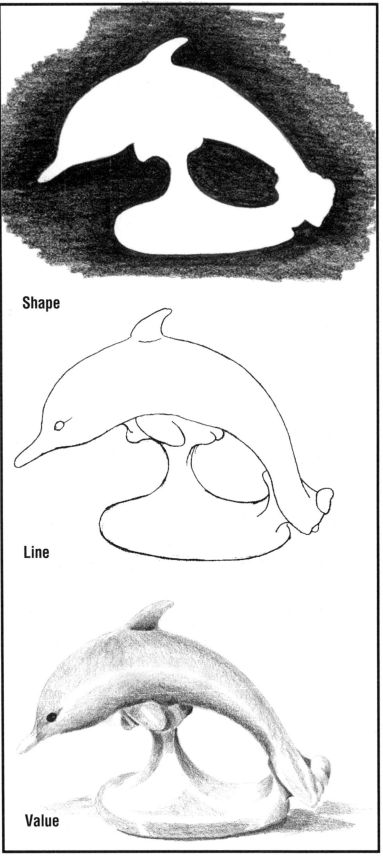

Shape

Line

Value

Instructions for shading exercises

Instructions: On the following pages, in box 1, you will see the object you are to copy. In box 2, using the grid, draw the negative space first, then in the same box, fill in the contour lines which delineate a map for shading. Next shade your drawing within the contour lines you have just established. Figure 47 demonstrates the sequence you will follow.

Now copy all the value drawings in this chapter.

Figure 47

Drawings by Gré Hann

Although your lines don't show when you graduate your values, it is important to shade in the proper direction so as to sculpt the object with your lines. In Box one you see a diagram which shows the contour line drawing of the pepper. Copy this in box 4. In Box 2, you will see a diagram that shows you which direction your strokes will take when you shade the pepper in Box 4. Don't use lines like the diagram, copy the shading style in Box 3 but make your shading follow the directions indicated in Box 2.

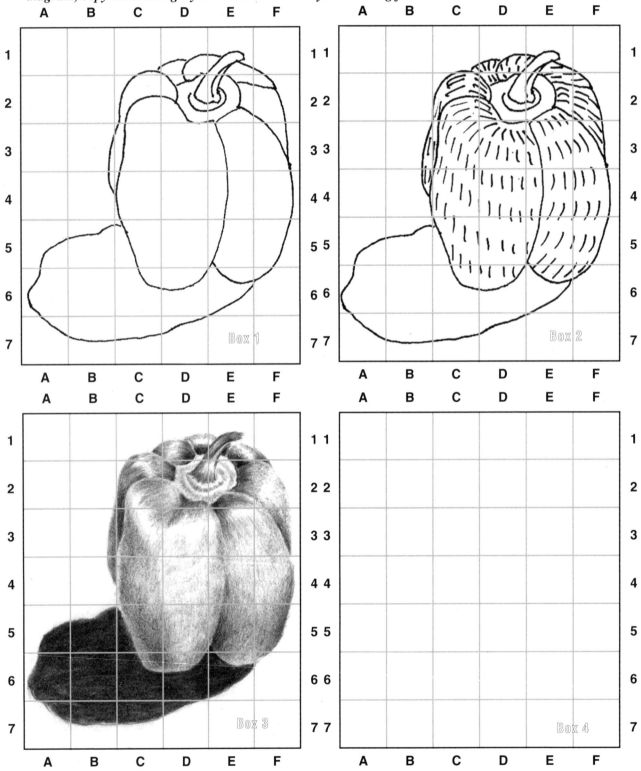

Value Exercises

Copy these drawings to learn shading techniques.

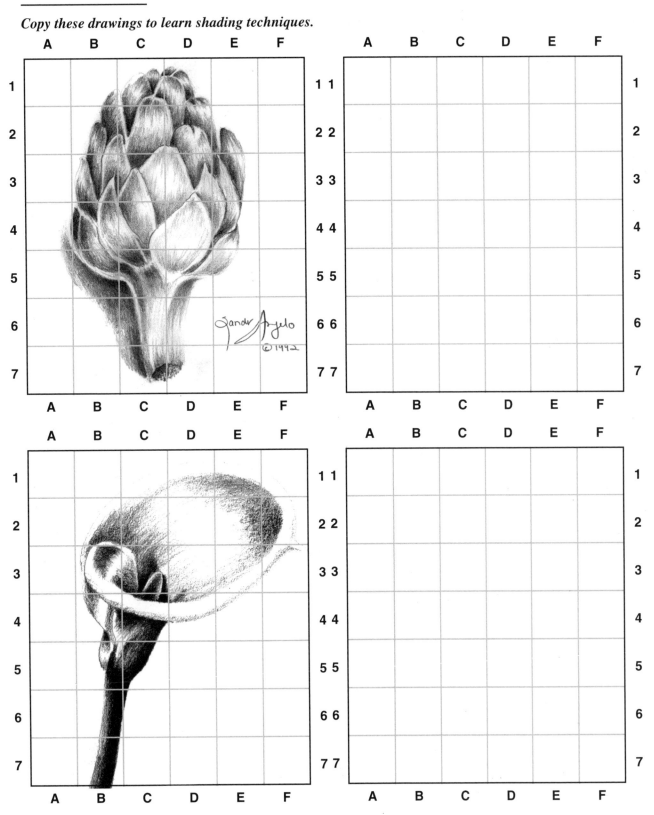

Value Exercises

Try these drawings on the practice paper. If it seems too hard, consider practicing just a few of the parts of the drawing.

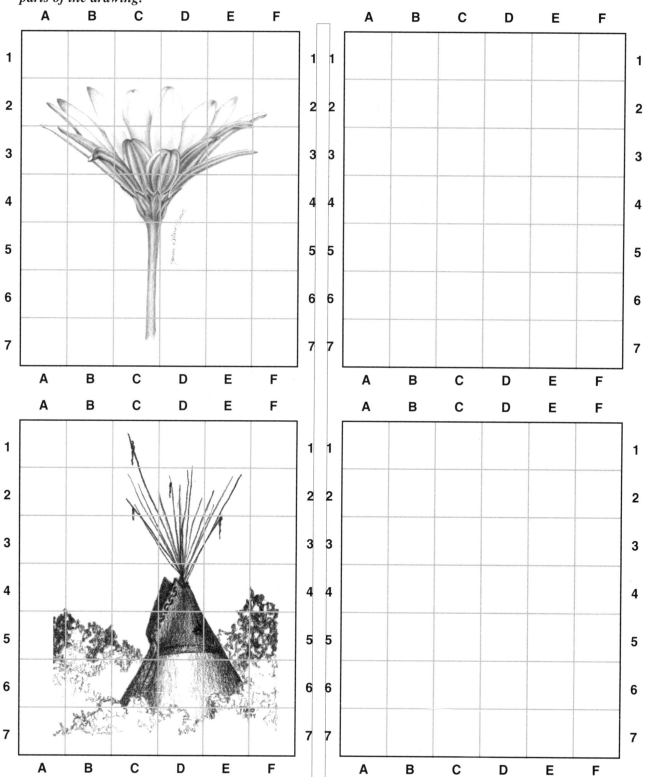

Value Exercise

Copy this value drawing in box 2 below.

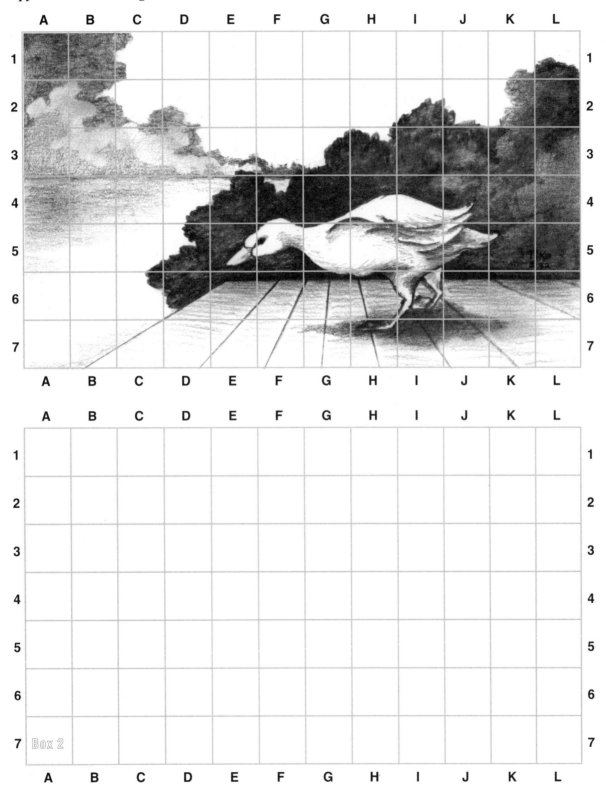

Drawing by Tiko Youngdale.

Value Exercise

Copy this value drawing in box 2 below.

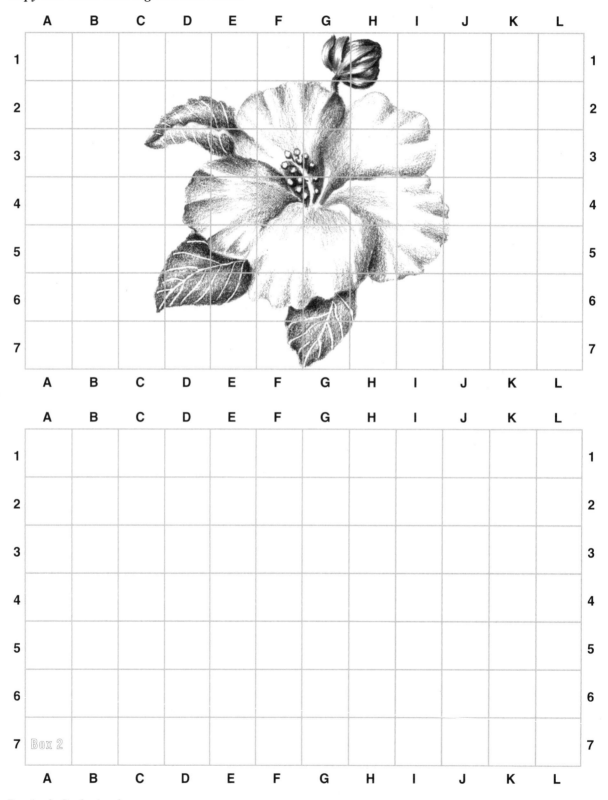

Drawing by Sandra Angelo

Value Exercise

Copy these value drawings in the boxes provided

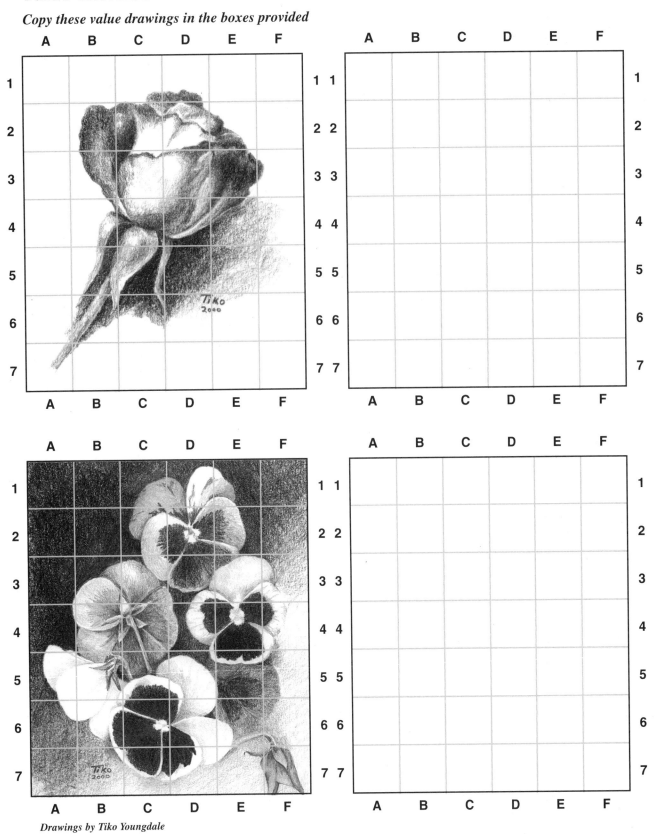

Drawings by Tiko Youngdale

CHAPTER SIX

CREATING TEXTURE

Fluffy flamingo feathers. Uncle Delbert's droopy jowls. Spido's cold wet nose. Dangling cellulite. Einstein's bad hair day. How do you create these various textures with the humble pencil?

Artists have come up with all kinds of elaborate strokes to simulate the textures they see around them, but the most commonly used textures are hatching and gradation.

Gradation: As we explained earlier, to graduate your strokes, use small circular marks, never lifting your pencil off the paper. Blend your strokes so that the lines do not show, thus creating a soft graduated value, i.e. the cat in Figure 48. As a general rule, this technique is used for objects that have smooth textures like the folds in fabric, saggy, baggy skin, a peach, a green pepper, a baby's cheeks, etc.

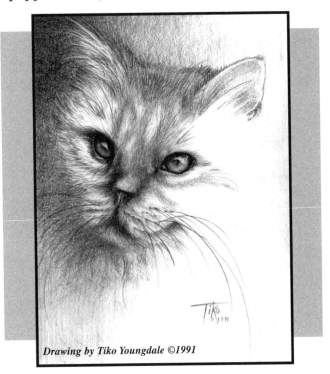

Drawing by Tiko Youngdale ©1991

Figure 48

Hatching: To create hatching lines, lift the pencil off the paper with each stroke allowing your lines to show. To change the lightness or darkness of your lines, simply use light, medium or heavy pressure on your pencil. See Figure 49. Another way to change values is to space the lines farther apart for light values and place them closer together to make the values dark. See Figure 50. As a general rule, hatching is used for objects which have a linear texture like human hair, grass, needles on a pine branch, a shaggy dog, a fluffy cat, Uncle Mortimer's toupee, etc.

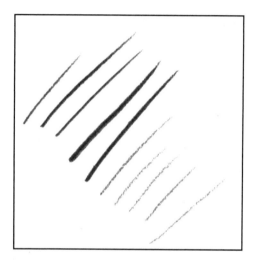

Fig. 49

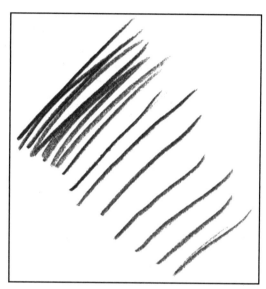

Fig. 50

Practicing Shading Techniques

Practice graduating your values by shading the rocks on page 69. If you'd like, you may draw the negative shape first, then draw the contour lines, and finally shade the values with graduated strokes. Blend your lines so they don't show. This will simulate the soft texture of these boulders. Remember, to get a dark value, press harder, to lighten your values, ease up on your pencil pressure.

TIP Never smudge your pencil lines with your fingers. Your B pencils (as in 2B, 3B, 4B...) will give you soft graduated values if you just keep going back over your lines, blending them gently. (The reason you have an impulse to smudge is because you are used to using the common HB household pencil. No matter how hard you tried, that pencil never blended unless you smudged with your finger.)

Shade these rocks with gradated values. Use hatching lines for the grass.

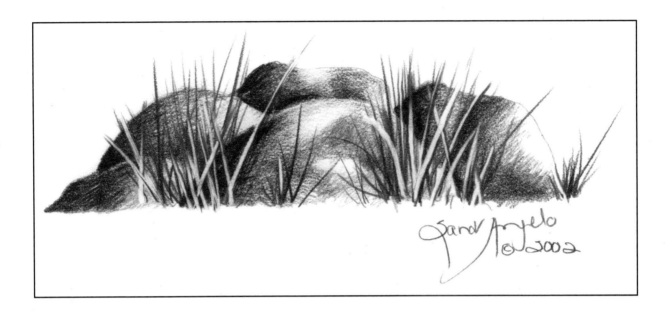

Now practice hatching by adding the grass to your rock drawing. Be sure to make your strokes go in various directions. Grass does not grow straight up. You can vary your values by changing your pencil pressure or by placing the strokes further apart. If you have a battery operated eraser, take out some of the dark values in the grass with the eraser.

Practicing Textures

There are other ways to create texture. You can vary your pencil pressure, twist it, push it, lay it on its side, etc. On page 80, try playing with your pencil to see how many different textures you can create by varying your strokes. Underneath each texture, describe how you created that texture. Then write down some uses for that type of stroke. For example, in Figure 51 you'll see that I laid the pencil on its side to simulate the bamboo handle. I then used the point of the pencil to create the goat hair brush.

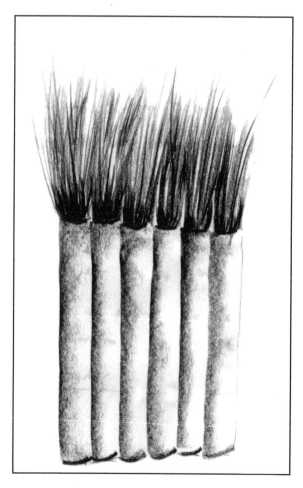

Figure 51: I used the side of my pencil to draw the bamboo handle and the point of my pencil to create the goat hair brush.

Look at the variety of textures I created by varying my pencil strokes. Next to my textures, I wrote down possible applications for these strokes.

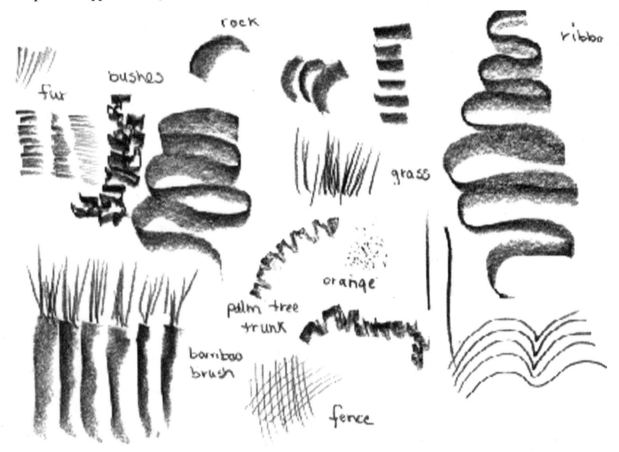

Now it's your turn. Fill this page with a variety of textures, using different kinds of strokes. For future reference, write down how you achieved each texture and ways you might use these marks in your drawings.

Begin to notice textures around you ...

Look at the four animals in Figures 52 through 55. Even though each of them have a linear hair pattern, every kind of fur has a different texture. Each animal's hair requires a different stroke. On the adjacent page, practice drawing each of these textures. You don't need to draw the whole animal, just do a little section and practice getting the appropriate texture.

Figure 52 *Figure 53*

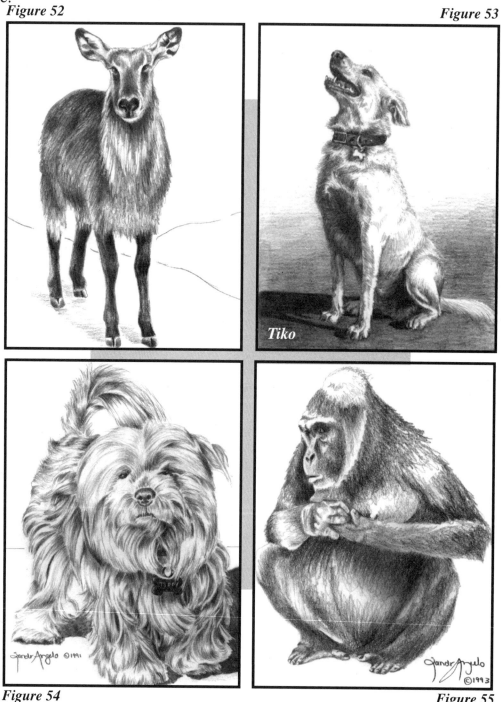

Figure 54 *Figure 55*

Even though all of these animals are covered with fur, the texture in each case is very different.

CHAPTER SEVEN

EXERCISE SECTION

TIME TO PRACTICE

Now you are going to practice texture by copying a wide variety of subjects. The following pages are full of drawings for you to copy. If you want to, you can use my four step drawing system for each of these drawings: 1) begin with the negative space 2) fill in the contour lines 3) shade the object and 4) apply the texture.

If you feel overwhelmed by any of the drawings, just practice parts of it, such as the tail, one leaf, one pumpkin, etc. After you practice the individual parts, you may be ready to tackle the whole drawing.

You don't have to do every drawing. Start with the ones which look easy and fun to draw. We all draw better if we are drawing something we like. An artist who loves land-scapes may draw faces very poorly simply because she doesn't enjoy it. We all do best at what we love so stay with the subjects that you enjoy until you have built some confi-dence and are ready to tackle more difficult drawings. If you like one of the subjects more than the others, try practicing it several times. You will improve your skills each time.

I have tried to group the drawings in their order of relative difficulty. For those of you who like structure, just follow the drawings in sequence. If you don't feel like going through the book sequentially, choose the drawings you like and do those first. Starting with easy drawings is critical, since it will insure success. Success breeds self confidence and confidence motivates you to practice. Practice creates an artist.

Instructions For Exercises

PART ONE

Practice makes artists.

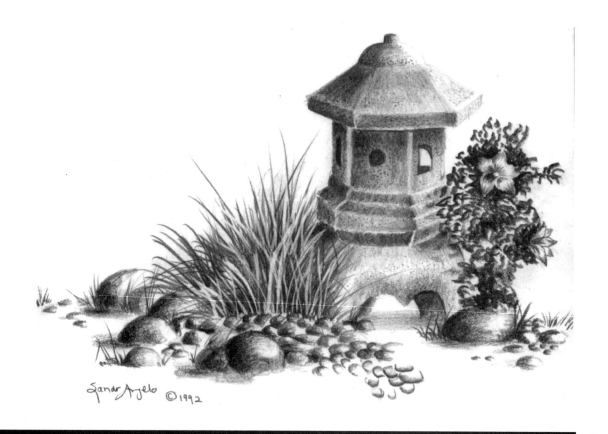

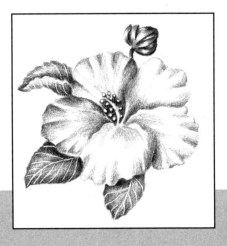

The following pages are filled with a variety of drawings for you to copy. Start with the subjects that you enjoy. If your first attempt isn't satisfactory, try practicing the parts; the tail, the ears, the legs, etc. Then try the drawing again.

Some beginners will end up becoming impressionists, meaning they will draw with loose lines like the ones Gré Hann used to shade her rabbit on page 87. People who like to use sketchy lines hate to draw small. If you fit into that category, you can do these exercises in a separate sketch book. Make the drawings as large as you like. For those of you who are Realists, you will be just fine drawing the petite, exact renderings in this book.

Remember to keep your sketch book private so that you will feel comfortable making mistakes. Review and follow the rest of the exercise instructions on page 39. If you get stuck on a subject, move on to something easier. Keep drawing the things you love because if you love it, you will make time for it and if you put in the time, you will automatically learn to draw.

If you get stumped, try eating a bowl of ice cream or a batch of chocolate chip cookies. Your drawing may not look better, but you'll feel great. Most of all, enjoy your drawing time. In the beginning, drawing is a bit stressful because you're no good at it. However, as your skills improve, you will find it to be one of the most therapeutic and relaxing exercises you can enjoy. So turn this page, and have fun!

As you practice your drawing on the following pages, you may want to use the four step process, as illustrated in this drawing of the dog. Draw the negative space first to be sure your placement is accurate. In the same box, fill in a contour line drawing which will serve as a map for your shapes and shadows. Shade your light and dark values and then place the texture on top of these values. This four step method helps you analyze each object in terms of its shapes, lines, values and textures. Eventually, you won't need to use this process because you will have trained your eye to see these elements.

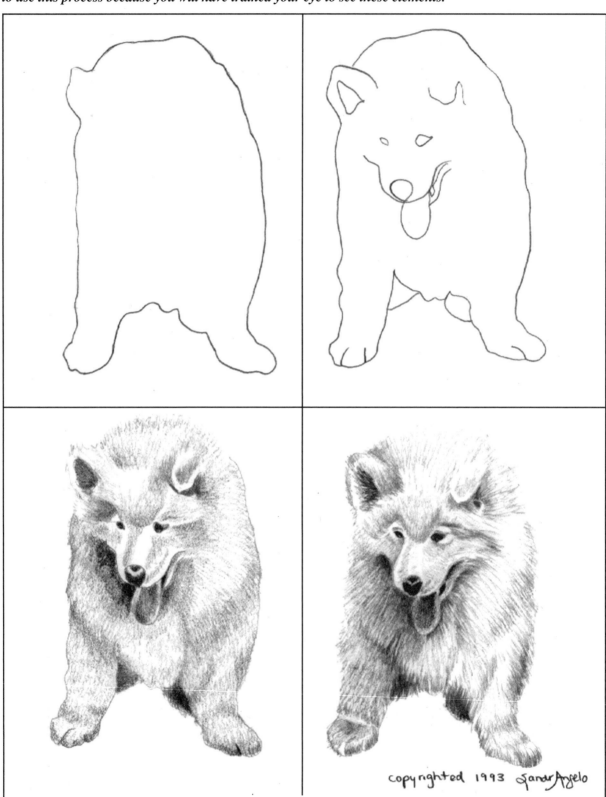

copyrighted 1993 Sandra Angelo

Fig. 57

Sometimes you only need three steps to complete a drawing, as in the flower below. In step one, I completed a negative space drawing. Then I created a map by putting in a contour line drawing, and finally I shaded the object. If your subject doesn't have a distinct texture, you can stop after step three.

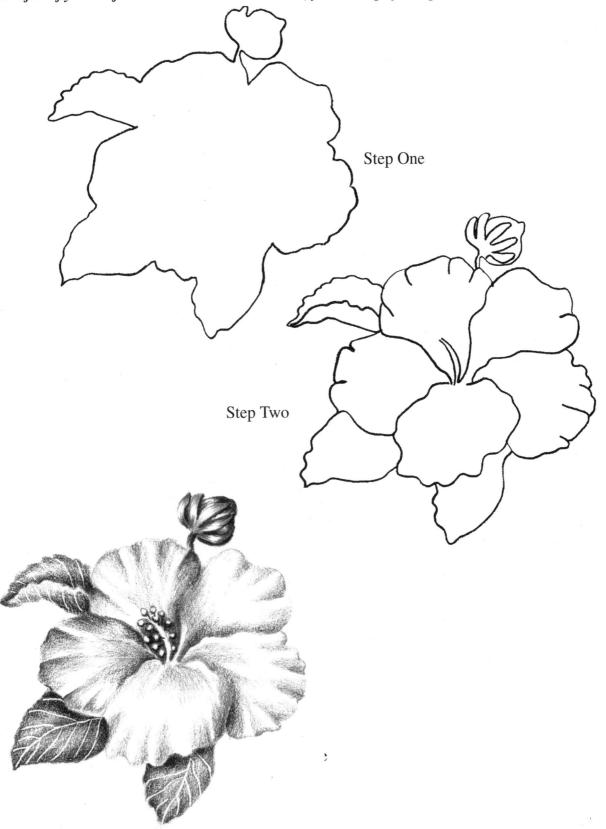

Step One

Step Two

In box 4, do a negative space drawing of the cow (see box 1). Then do a contour line drawing of the cow inside this negative space drawing (see box 2). Finally, shade the cow with the same textures you see in box 3.

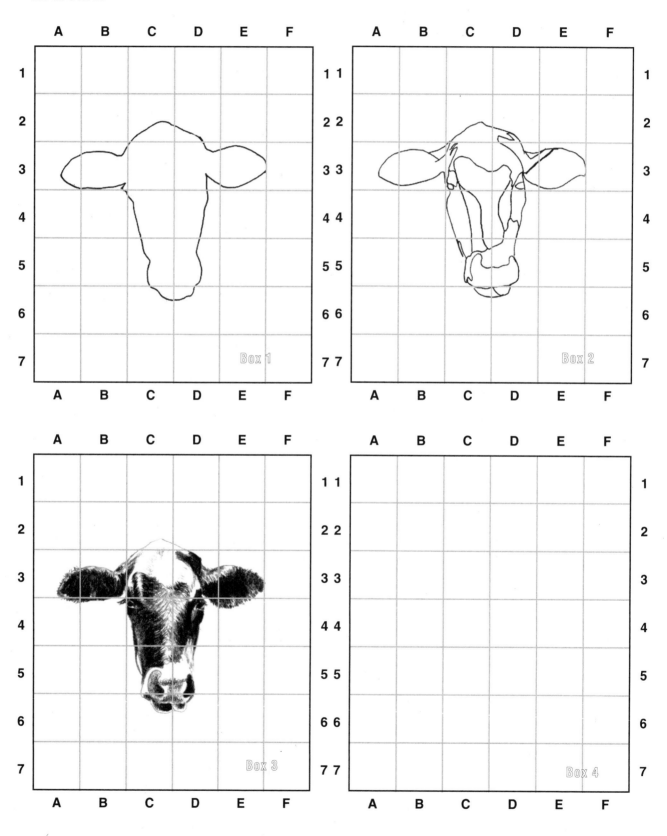

Try this drawing on the practice paper. If it seems too hard, consider practicing just a few of the parts of the drawing. If the subject doesn't interest you, you can skip to the next drawing.

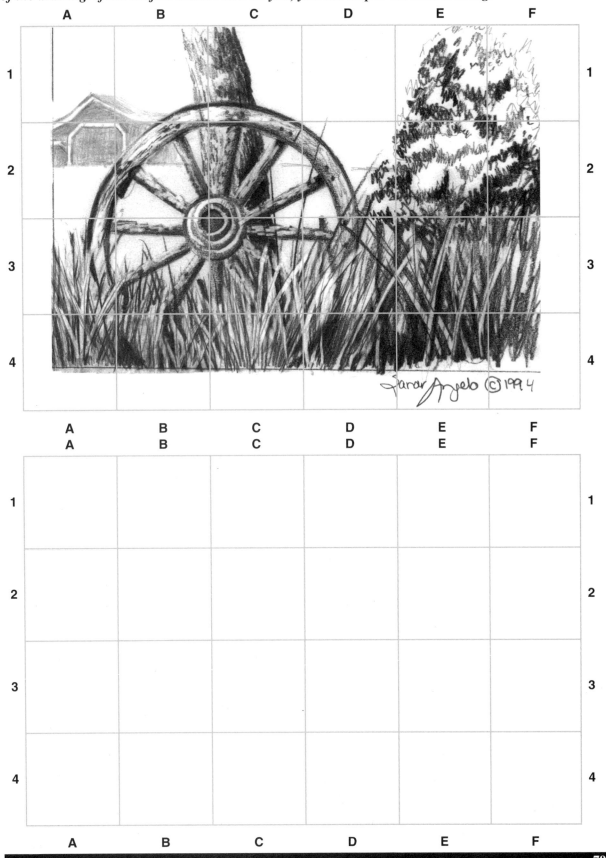

To make your life easier, I have provided a step-by-step drawing of this subject. In Box One, you will see the negative space drawing of the subject. Draw this negative space in Box Four. In Box Two, you will see a contour line drawing of the subject. Complete a line drawing inside the negative space in Box Four.

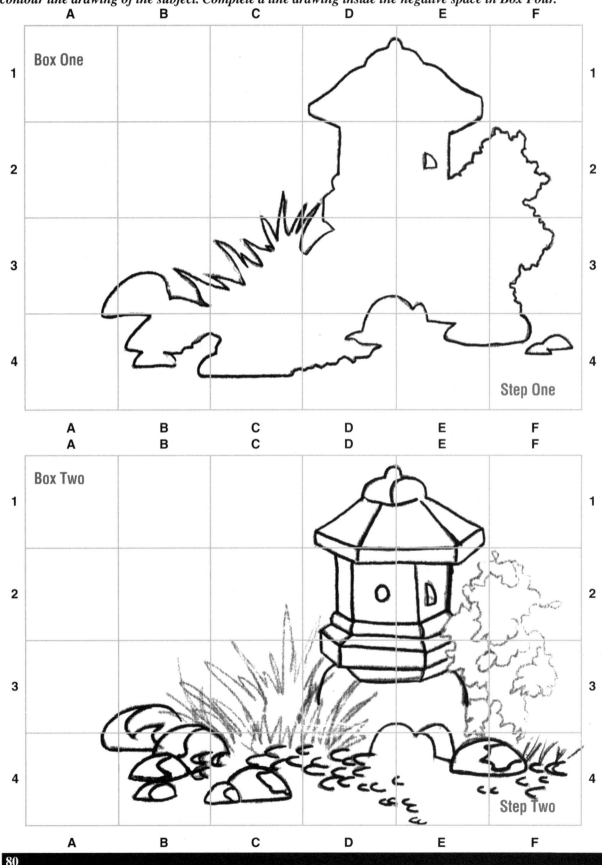

Box One

Step One

Box Two

Step Two

Place the values and textures inside the lines in Box Four.

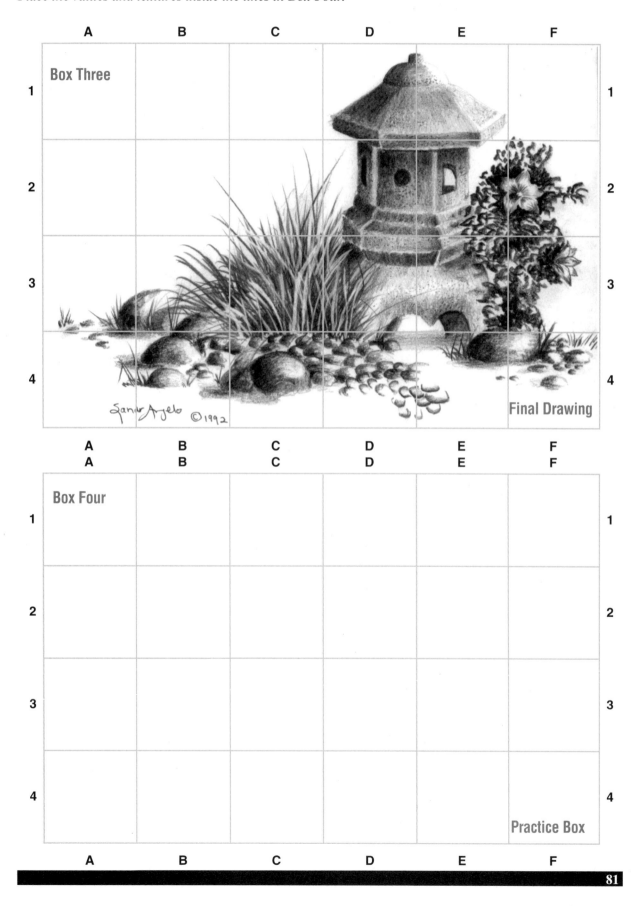

Draw this flower in the box below.

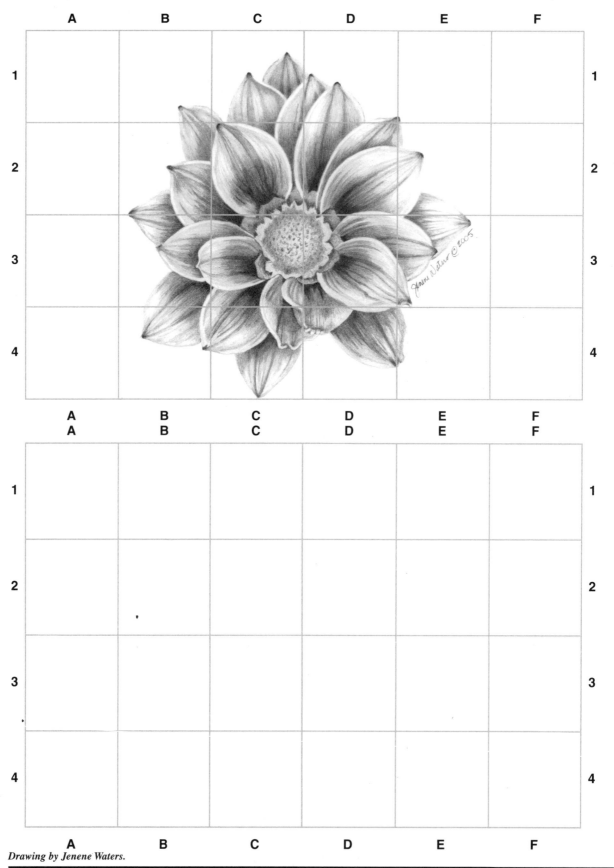

	A	B	C	D	E	F

	A	B	C	D	E	F

Drawing by Jenene Waters.

Copy this drawing in the box below.

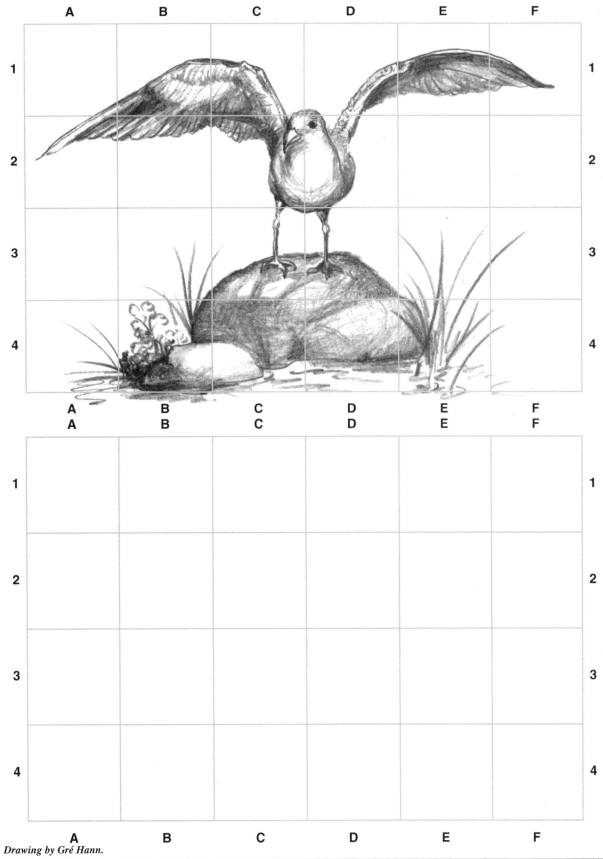

Drawing by Gré Hann.

Copy this drawing on the following page.

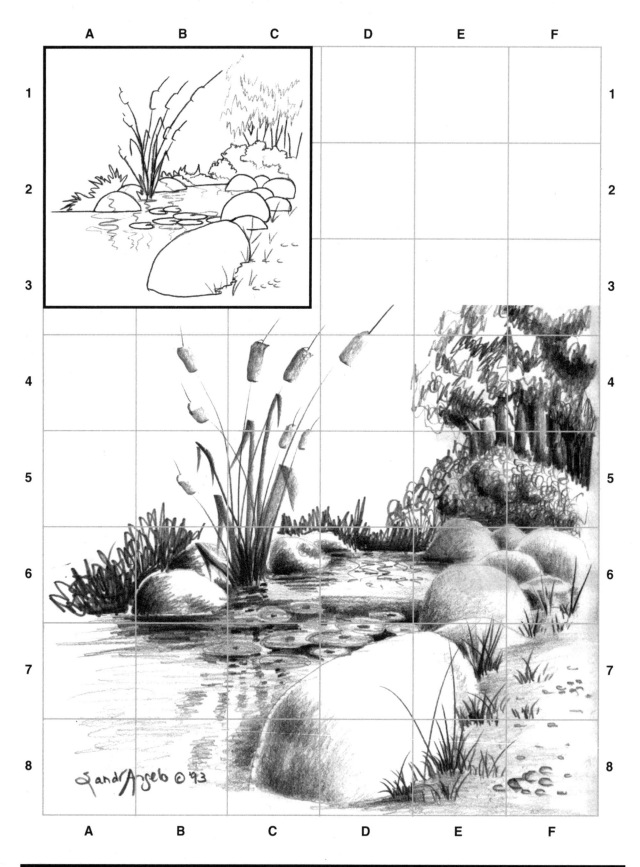

Practice Page

	A	B	C	D	E	F	
1							1
2							2
3							3
4							4
5							5
6							6
7							7
8							8
	A	B	C	D	E	F	

Draw this car in the box below.

Copy this drawing in the box below.

Gré Hann

Copy these trees on the following page. If you're having trouble, practice small parts.

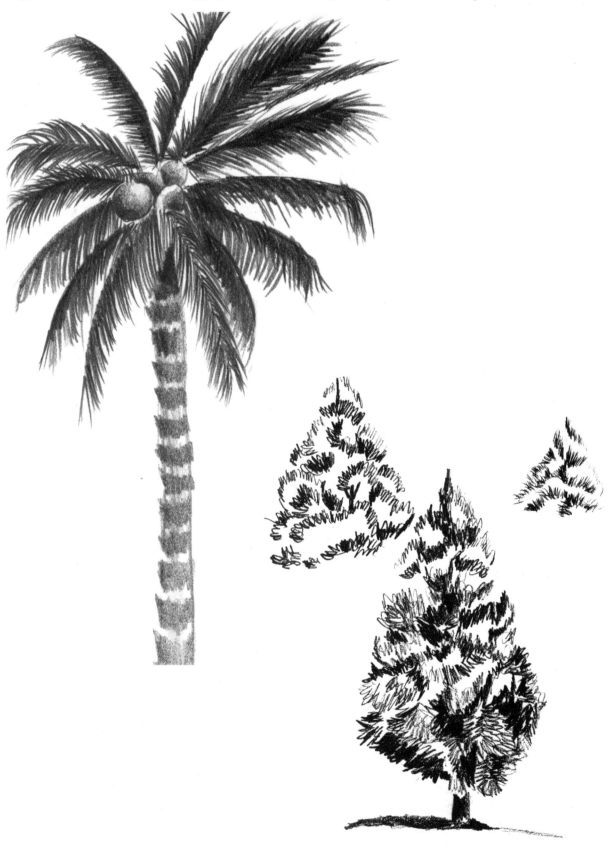

Practice Page

Copy this teddy bear in the gridded box on the adjacent page.

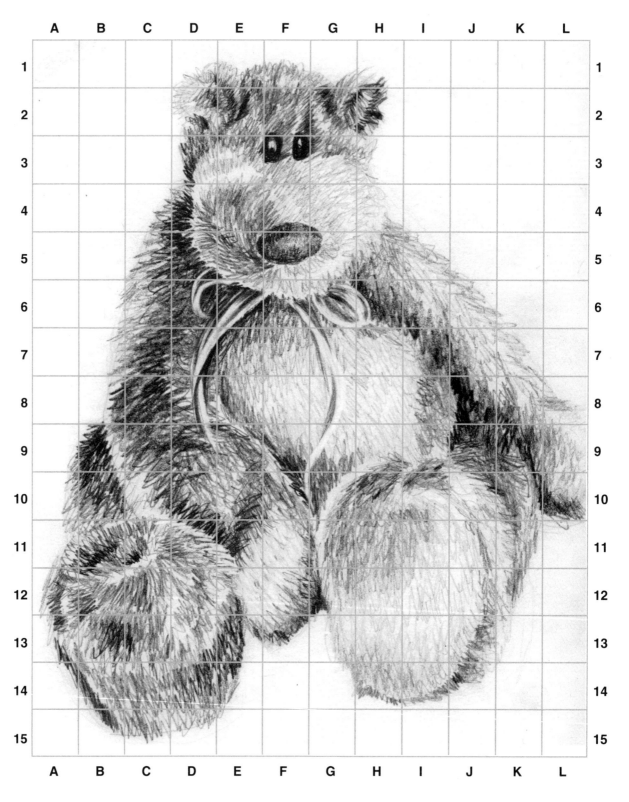

Drawing by Sandra Angelo ©2004

Practice Page

Copy this drawing on the practice page.

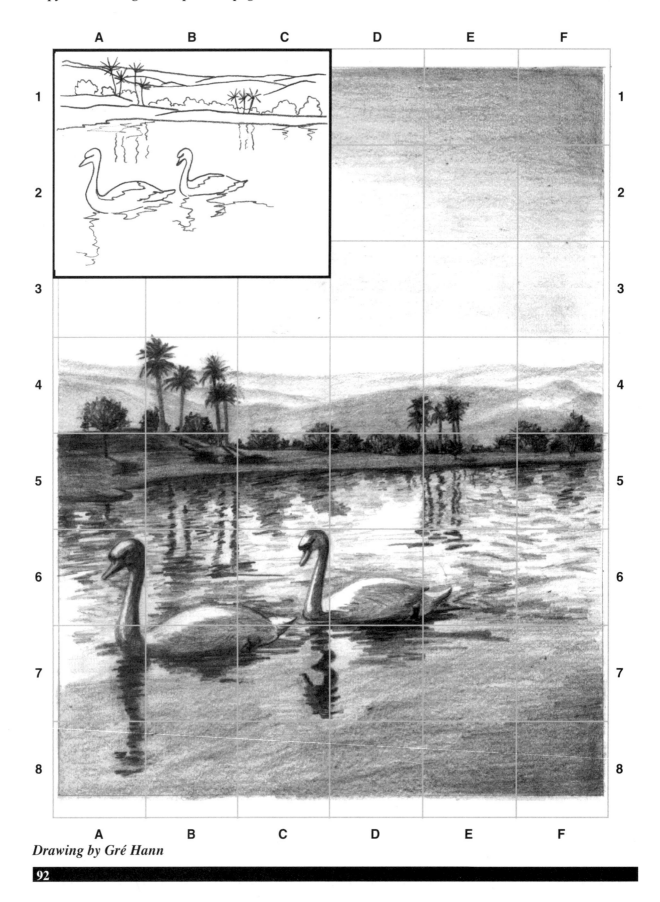

Drawing by Gré Hann

Practice Page

	A	B	C	D	E	F	
1							1
2							2
3							3
4							4
5							5
6							6
7							7
8							8
	A	B	C	D	E	F	

Copy this drawing on the practice page. If any of the squares are too complicated, subdivide them.

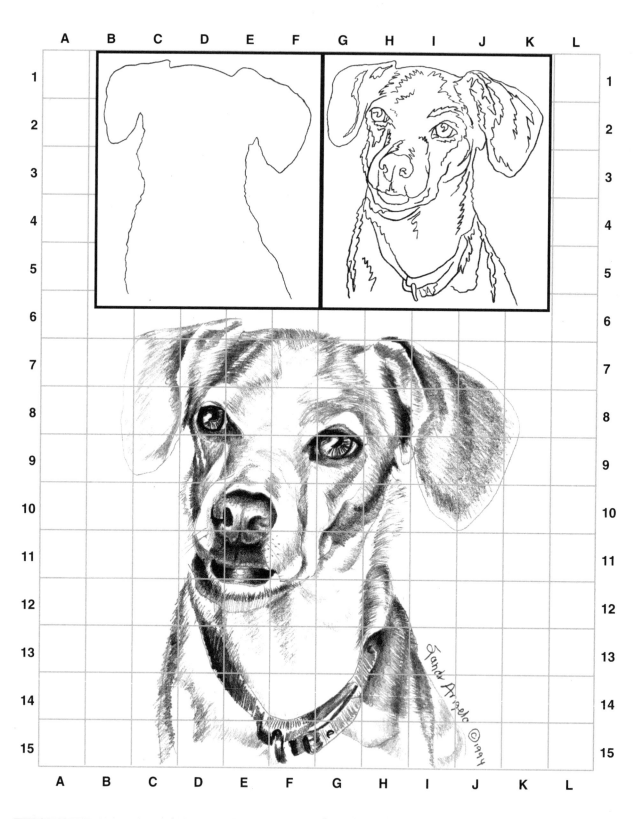

Practice Page

Copy this drawing on the practice page.

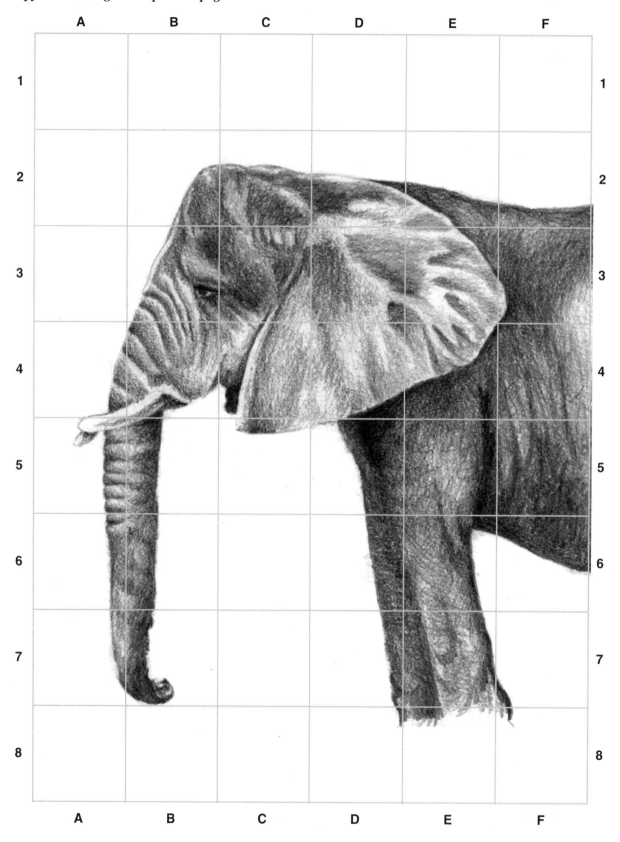

Practice Page

	A	B	C	D	E	F
1						
2						
3						
4						
5						
6						
7						
8						

Copy this drawing on the practice page.

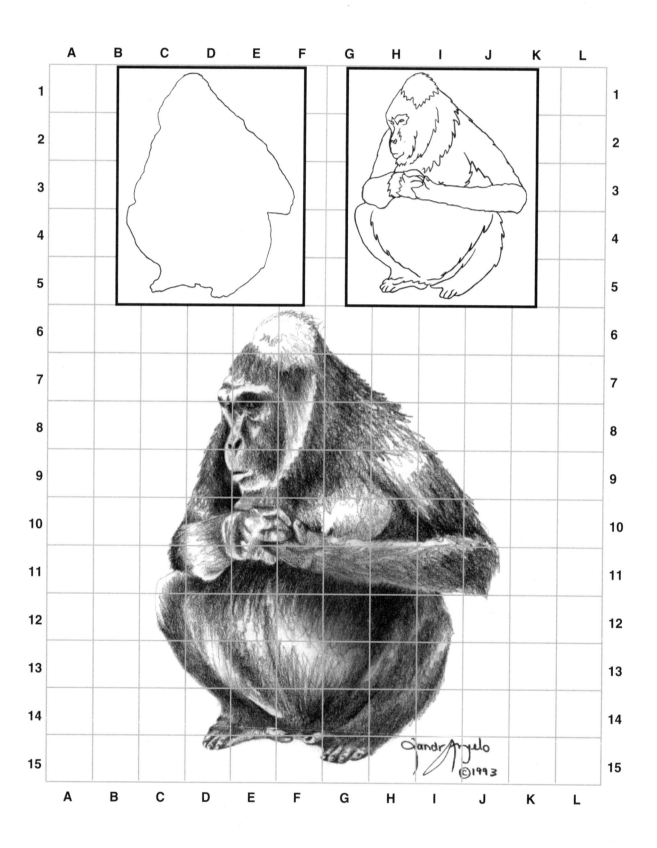

Copy this drawing on the practice page.

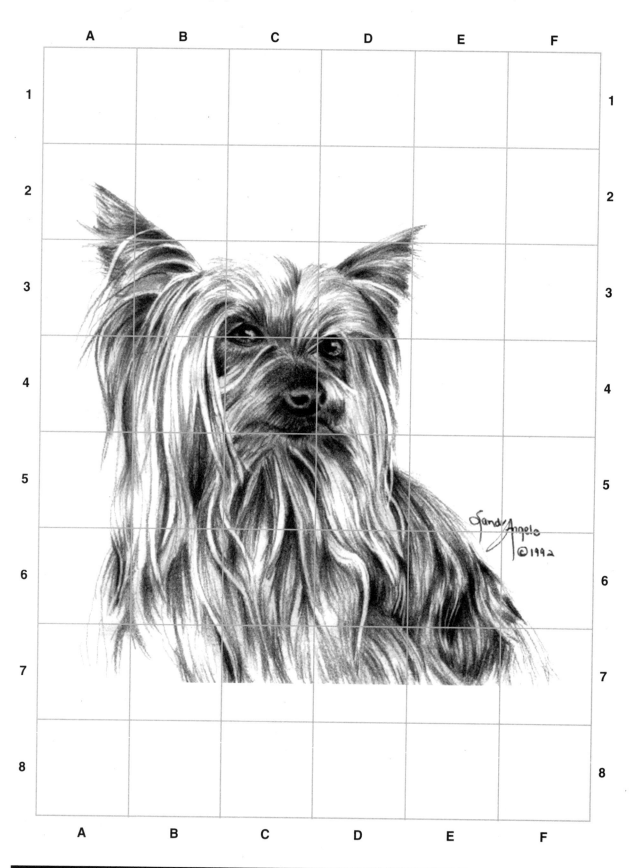

Practice Page

	A	B	C	D	E	F	
1							1
2							2
3							3
4							4
5							5
6							6
7							7
8							8
	A	B	C	D	E	F	

Practice this drawing on the following page.

Practice Page

	A	B	C	D	E	F	
1							1
2							2
3							3
4							4
5							5
6							6
7							7
8							8
	A	B	C	D	E	F	

Practice this drawing on the following page.

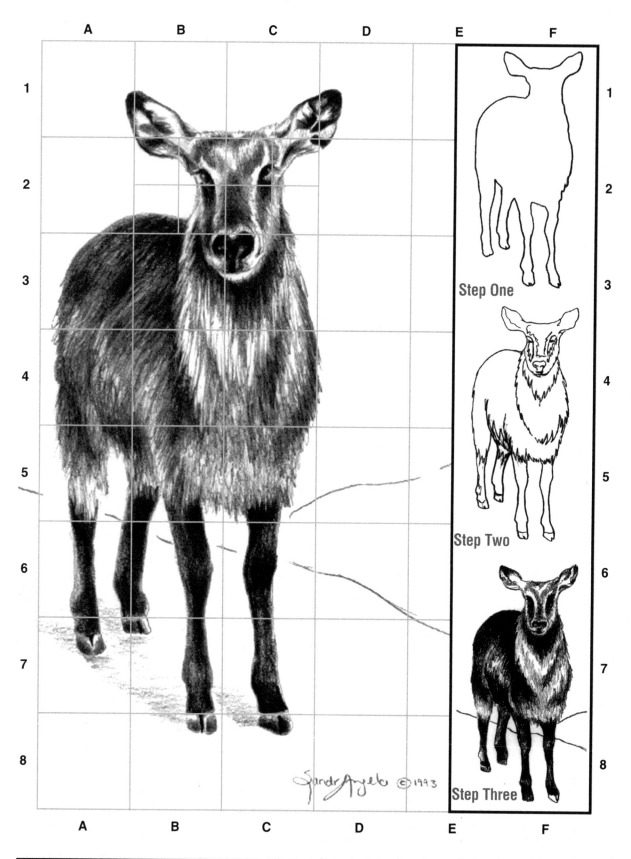

Step One

Step Two

Step Three

Practice Page

	A	B	C	D	E	F	
1							1
2							2
3							3
4							4
5							5
6							6
7							7
8							8

| | A | B | C | D | E | F | |

Practice this drawing on the following page.

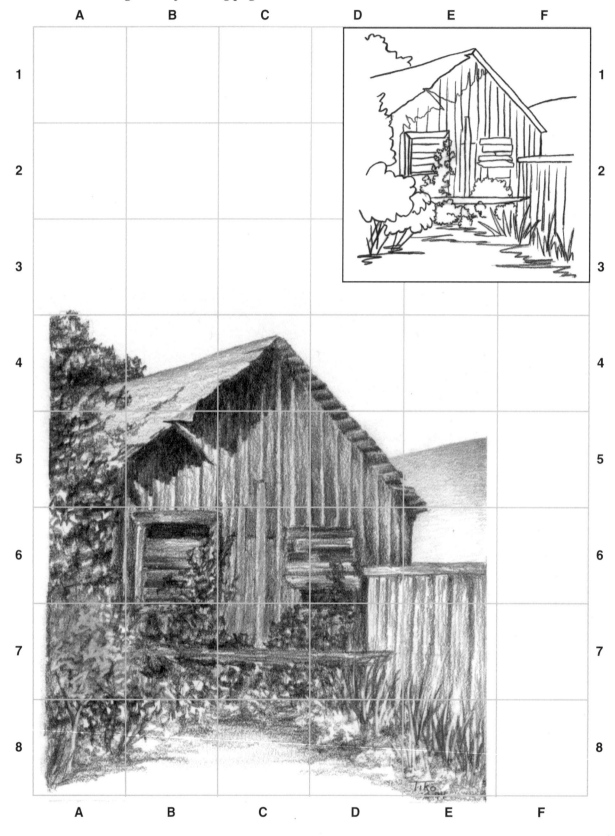

"Wallowa County" by Tiko Youngdale

Practice Page

	A	B	C	D	E	F
1						
2						
3						
4						
5						
6						
7						
8						

Practice this drawing on the adjacent page.

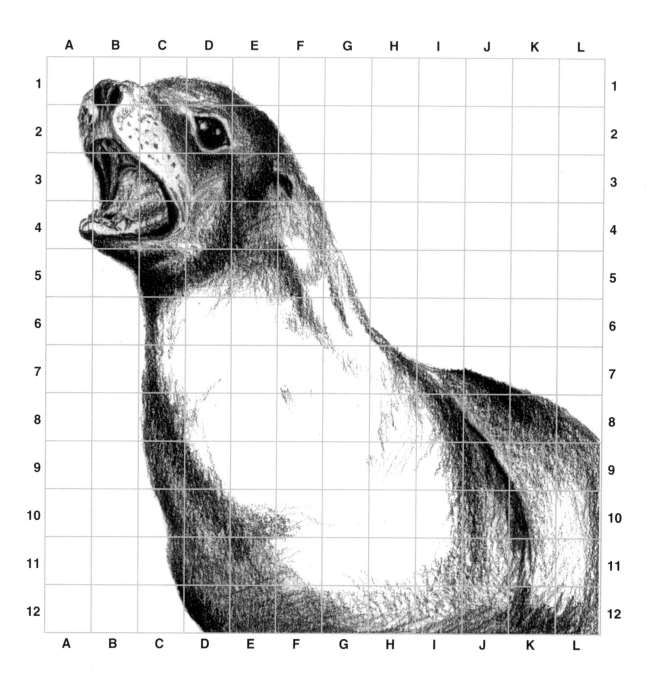

A B C D E F G H I J K L

Drawing by Gré Hann.

Practice Page

Copy this drawing on the practice page.

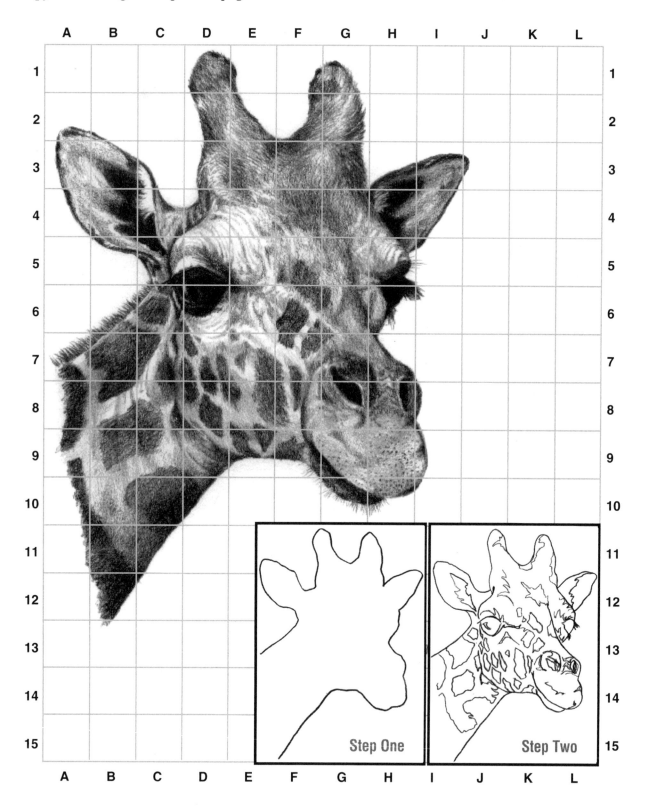

Step One

Step Two

Drawing by Tiko Youngdale.

Practice Page

Practice this drawing on the grid below.

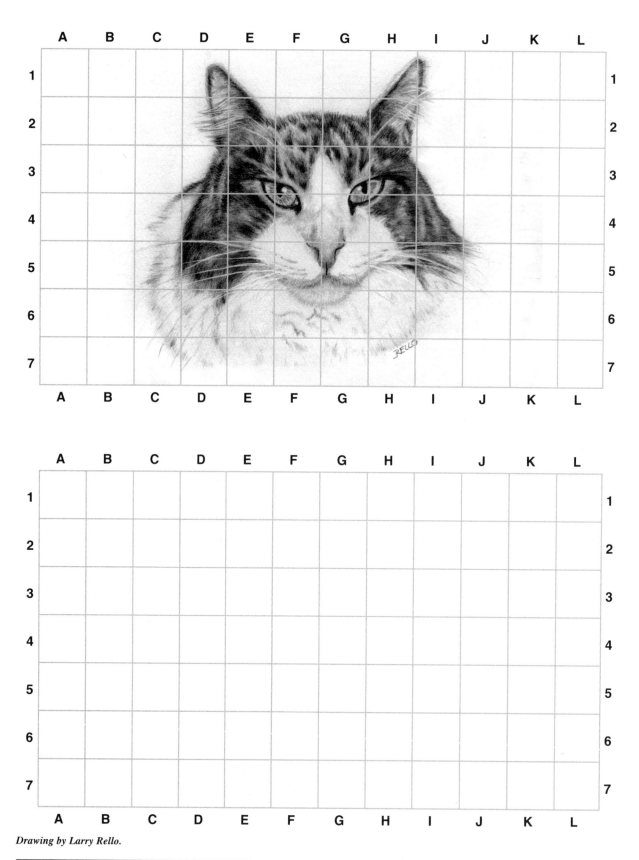

Drawing by Larry Rello.

Practice this drawing on the grid below.

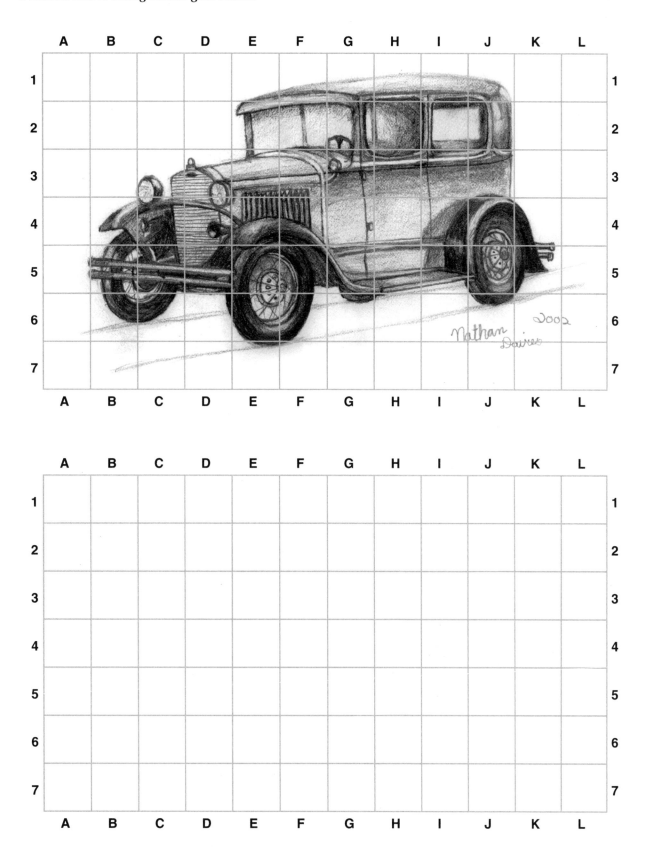

Copy this drawing on the practice page.

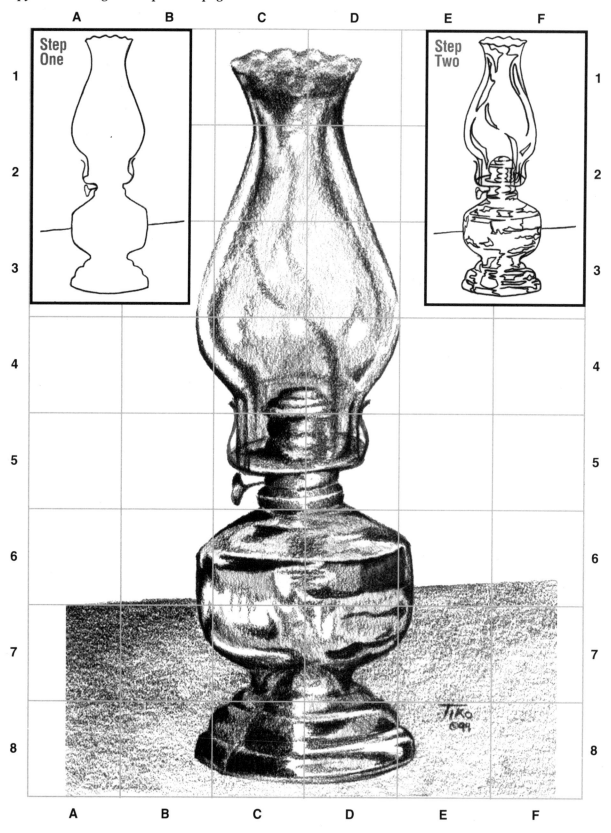

Drawing by Tiko Youngdale.

Practice Page

	A	B	C	D	E	F
1						
2						
3						
4						
5						
6						
7						
8						

Practice this drawing on the following page.

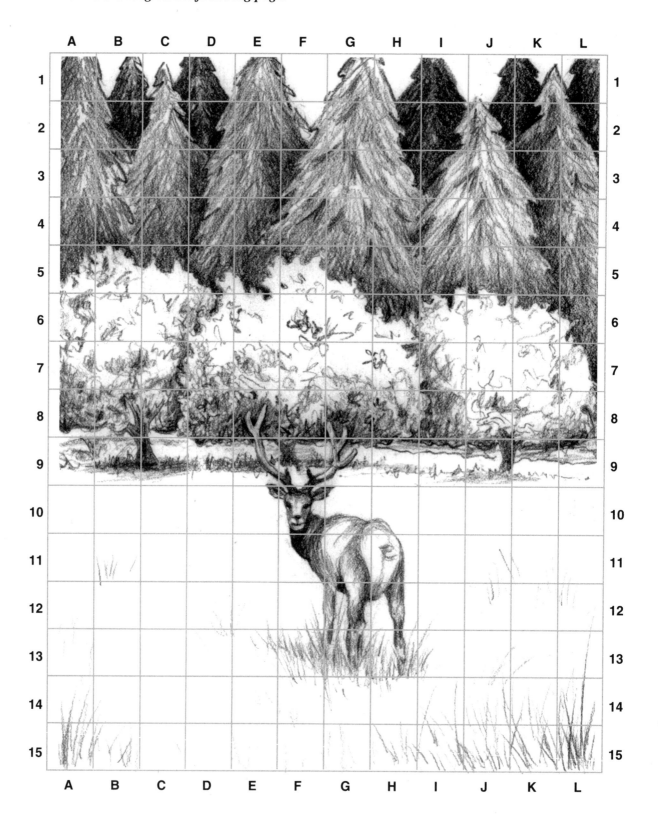

Drawing by Gré Hann.

Practice Page

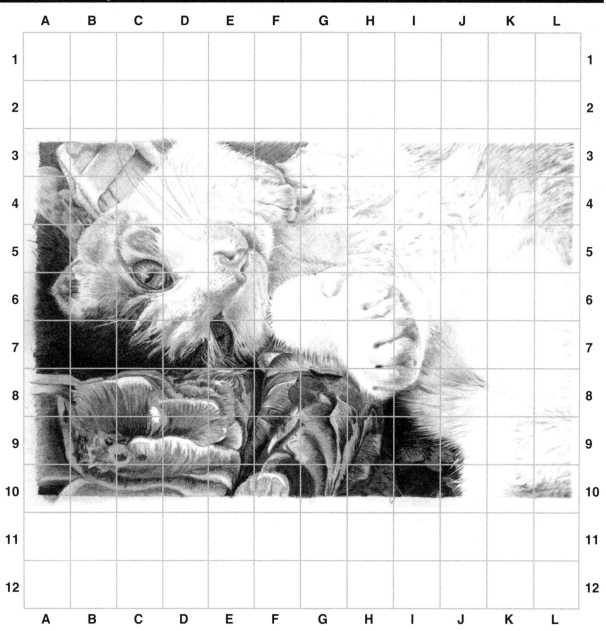

Sandy Skillern started drawing with me about 10 years ago. She has progressed so far that she has now completed creative drawings of every single one of her grand babies and grand cats. This is one of her grand cats.

Drawing by Sandy Skillern.

Practice Page

Practice this drawing on the following page.

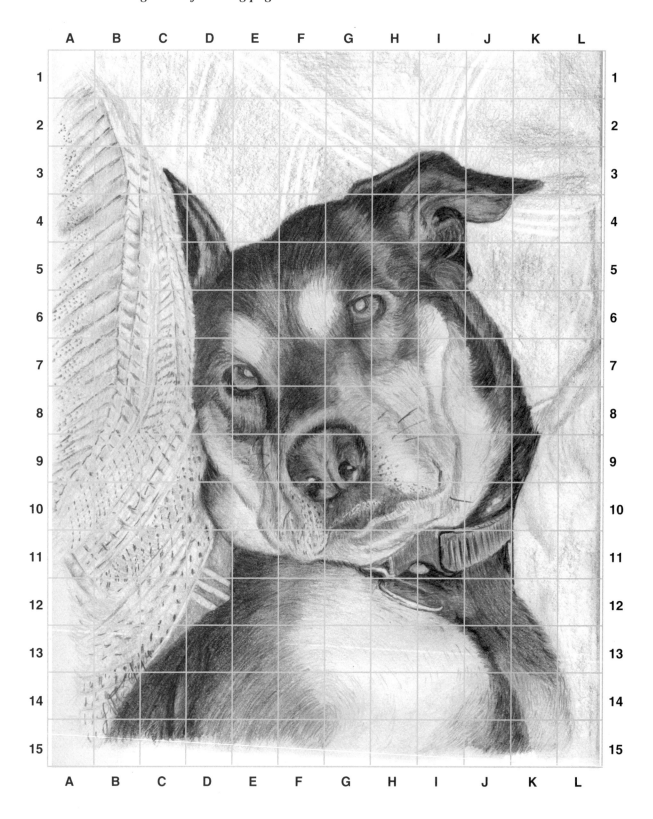

Drawing by Larry Rello.

Practice Page

Practice this drawing on the following page.

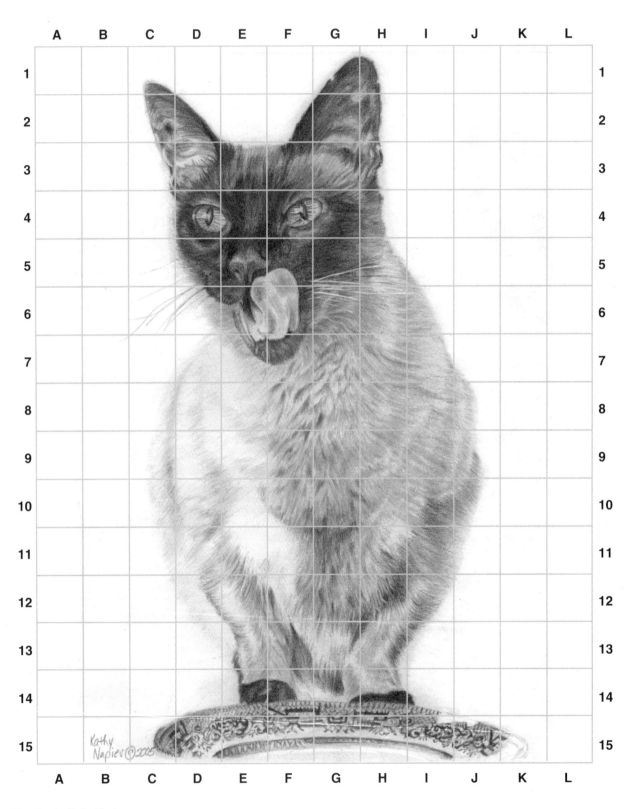

Drawing by Kathy Napier.

CHAPTER EIGHT

Drawing From Photo References

Now that you've conquered copying the masters, try raising the level of difficulty by working from photos. This will be a bit harder because now you have to decide what kind of stroke you will use to create each texture.But your work with the masters has taught you a variety of shading techniques so you should be able to handle this transition fairly well. To make your move easier, I have made all the photos black and white, thus solving the value equation for you (how light or dark the item is).

This picture is typical of the photos most people take with a small home camera. The baby gorillas' heads are the size of the thumbnail on a small pinky finger. You simply can't draw from a photo like this because the subject isn't large enough to see the details. And to make matters worse, the lighting is very poor.

This close up of the gorilla is much better, because it's a 5x7 print, the subject fills the whole frame, the lighting is good, all of which contribute to more detailed information for drawing.

The photos I have supplied are fairly simple in terms of subject matter. When you finish these, I recommend that you draw from some of your own photos. Here are the rules you need to follow when selecting reference photos.

1. **A good photo equals a good drawing**. Memorize this. Countless hours are spent laboring over bad photos trying to create a good drawing. There are plenty of photos that are excellent references. Why waste your time on a bad one?

This is especially true for beginners. You must have early success to stay motivated and if your snapshots are complicated or poor quality, you will fail. If you don't succeed, drawing will become a chore instead of a pleasure, and you'll stop practicing.

2. **Make sure the photo is large enough so that you can see the details**. Students frequently come to me with a drawing that was done from a reference where the child's face was smaller than my pinky fingernail. And they are wondering why they can't get a likeness. If you can't see the details, you can't draw them! Draw from large photos.

You can enlarge photos quickly on a color copier or a computer printer. (If you want to solve the value equation, use the black and white setting .)

This photo would be easy to draw because the subject matter is uncomplicated.

This photo is too complicated for a beginner.

3. **Choose simple references at first**. When you switch to a new level of difficulty, you need to maximize the possibility of success. Choosing uncomplicated, simple subjects helps build early achievement and motivates you to practice. Practice in turn, makes you better.

Caution: Don't choose photos that need to be modified. That's too hard for a beginner. After you have mastered the ability to copy exactly what's in a photo, you can learn to modify what you see.

In my book and video collection titled, *Turning Family Photos into Art*, and, on the video titled, *Creating Dynamic Compositions, What do I do with the background?*, you will be given more information about formal composition. At this stage, however, you should not try to draw creative masterpieces. Just practice copying textures. Being creative requires some fairly advanced skills.

4. **Draw subjects you love**. If you love the subject you are drawing, even tedious detail won't seem tough. I can draw a tiger with lots of stripes and purr the whole time whereas that much detail in a tree would send me over the edge!

5. **Carry your camera everywhere**. You never can tell where you'll spot a great subject. One day, I was in the park when I came across a basset hound parade and saw this man and his pooch watching the craziness. I always cart my camera so I was able to capture the whole silly scene on film.

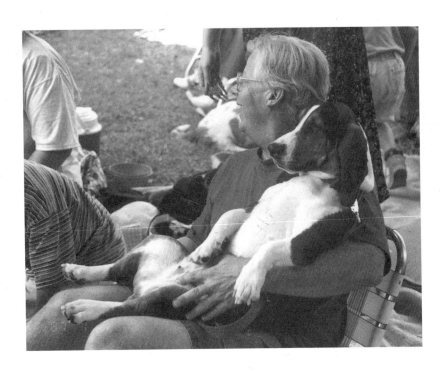

6. **Choose photos with a wide range of values**. Light and dark values define the underlying structure of an object. i.e. When there is a bone or muscle under fur, you'll see a shadow. Sometimes when you use flash on a white or black object, all the shadows will disappear and you won't be able to see the foundational structure or anatomy. If you use natural light, there is usually a full range of values, unless it's a black object in full sun like the photo of the cow below.

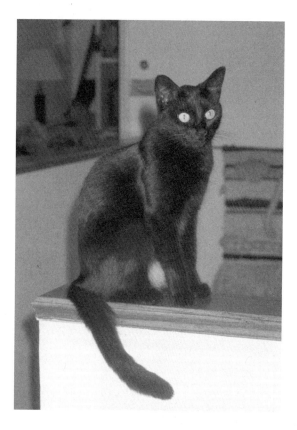

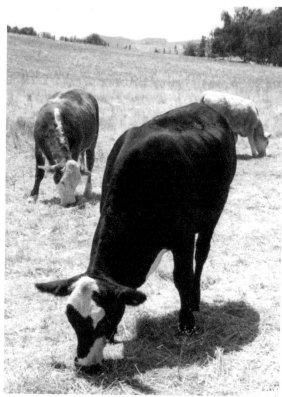

This photo captures the wide range of values in the cat, showing the contours which suggest the underlying anatomy.

Since this was taken in strong sunlight, most of the black cow is hidden in shadow. It would be very difficult to draw this because there is not a good range of values.

7. **Reference photography is different than artistic photography**. When you are shooting to create a fabulous photo, you must pay careful attention to the principles of composition. With reference photos, you are simply looking for detailed information. I always shoot my subjects from several different focal lengths: i.e. If I was photographing an animal, I shoot a close up of the eye, the nose, the ear, a shot of the head, a shot of the whole body, a shot of the body in the landscape, etc. Take all detail shots from the same angle.

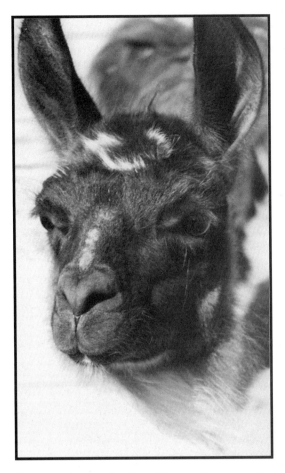

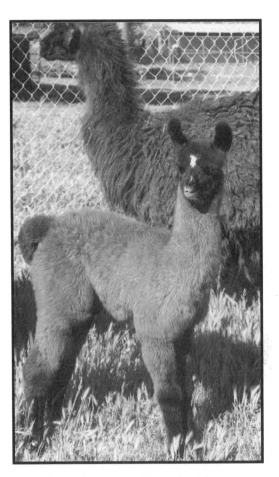

Because I was simply taking references, I was not concerned that the llama in the background was cut off. I simply wanted a shot of the full body of the llama. I then pulled in for a close shot of just the head so I could see the detailed textures of the face.

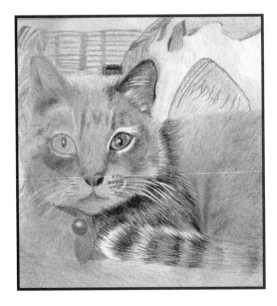

The number one mistake that beginners make when working from a photo is this: Not using a full range of values. This cat was drawn by a beginner. I corrected it on the right side to demonstrate that more light, medium and dark values were needed. You can see that when there is a wider range of values, there is much more depth.

You don't have to copy your photo exactly. Sometimes you can zoom in, leaving everything out except for the key subject. I call this "drawing only what you need to know."

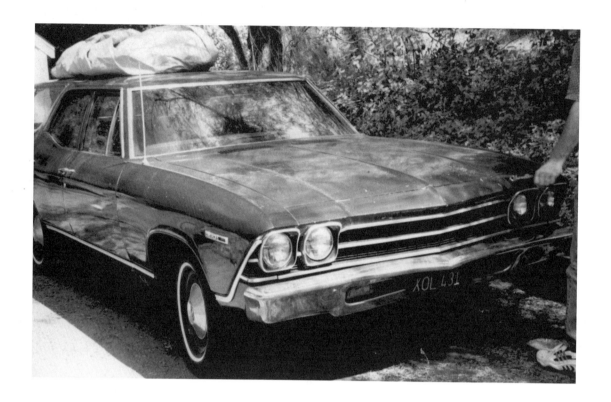

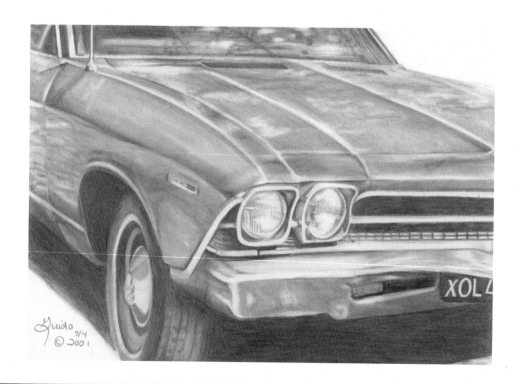

Draw this alpaca in the matching gridded box. If you prefer not to use a grid, draw the subject in your sketchbook. If you find it difficult to draw the background, just leave it out.

Although this is a good reference, it's hard to see Ashes' eyes, so Barbara shot a close-up of her cat. See page 129. It's a good idea to take detail shots from the same angle, the same day, if possible.

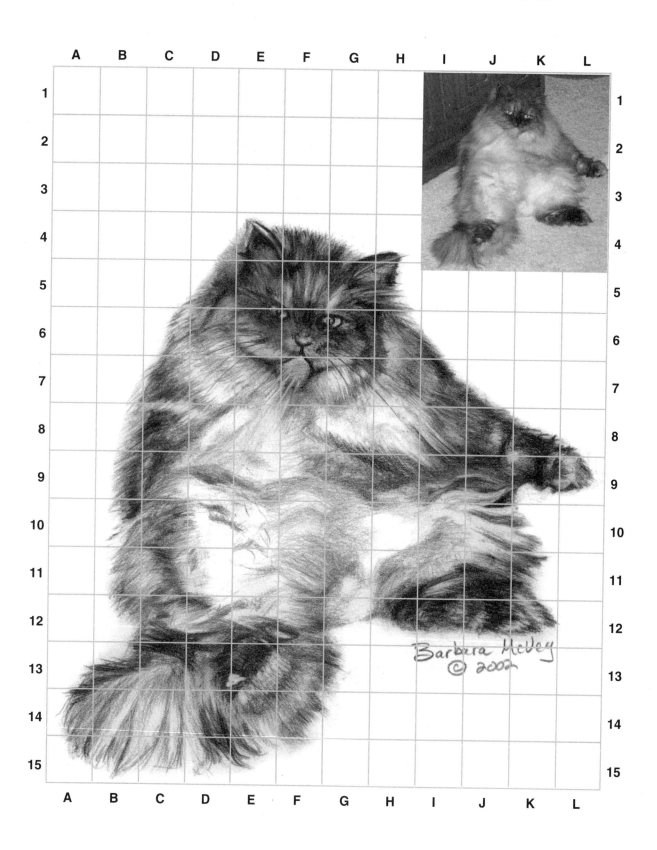

Barbara McVey
© 2002

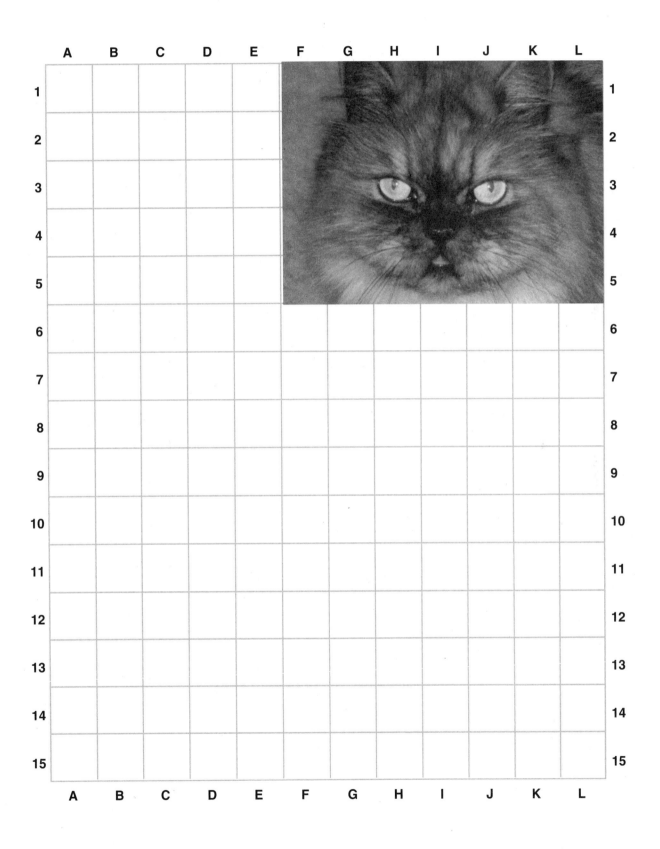

Draw this subject in the matching gridded box. If you prefer not to use a grid, draw the subject in your sketchbook. If you find it difficult to draw the background, just leave it out.

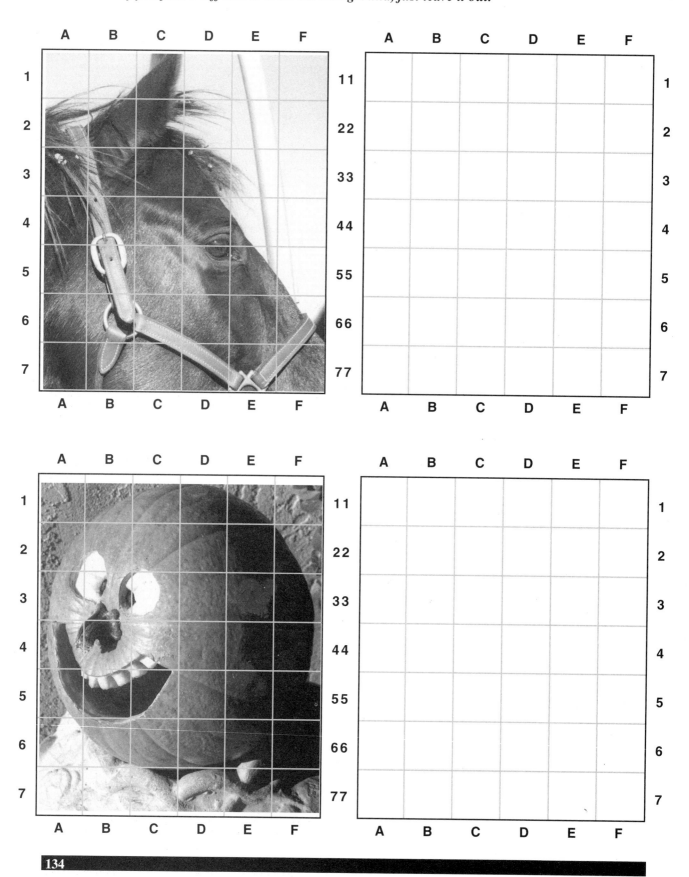

Draw this subject in the matching gridded box. If you prefer not to use a grid, draw the subject in your sketchbook. If you find it difficult to draw the background, just leave it out.

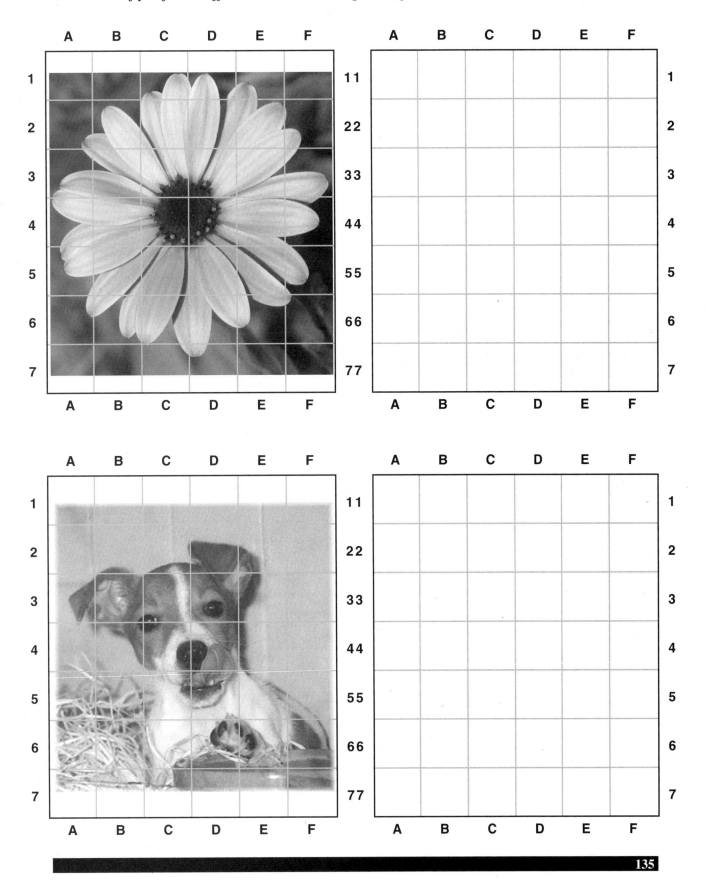

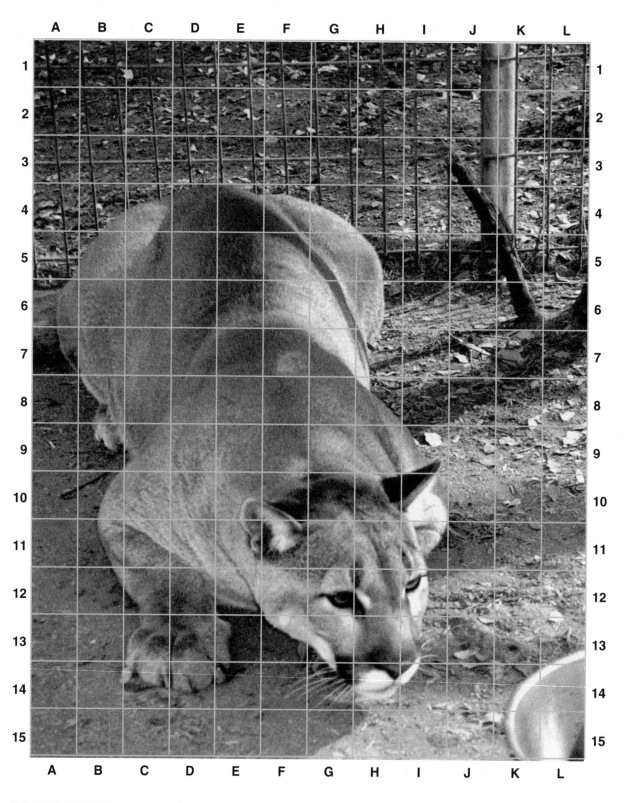

Starting out as a novice, Larry Rello completed this entire book and then drew this remarkable rendering of the mountain lion on Page 134. If you'd like to draw this too, place a 1/2 inch grid kit under a page in Sandra's Favorite™ sketchbook and draw.

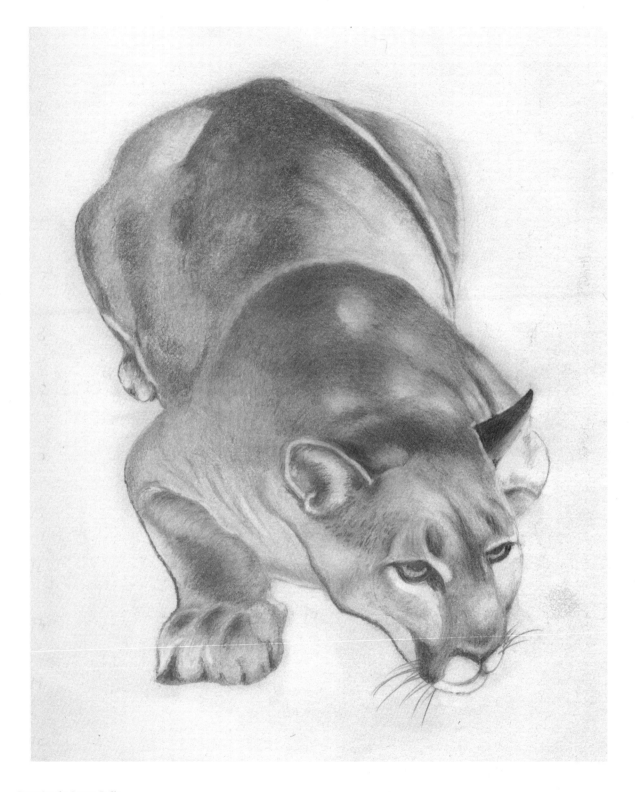

Drawing by Larry Rello.

Draw this cockapoo in the matching gridded box. If you prefer not to use a grid, draw the subject in your sketchbook. If you find it difficult to draw the background, just leave it out.

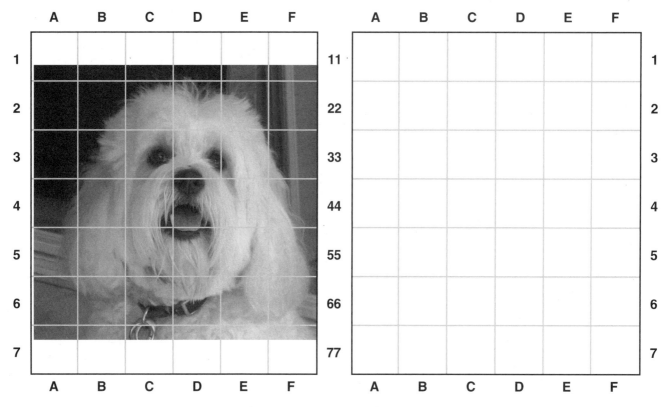

Draw this hibiscus in the matching gridded box. If you prefer not to use a grid, draw the subject in your sketchbook. If you find it difficult to draw the background, just leave it out.

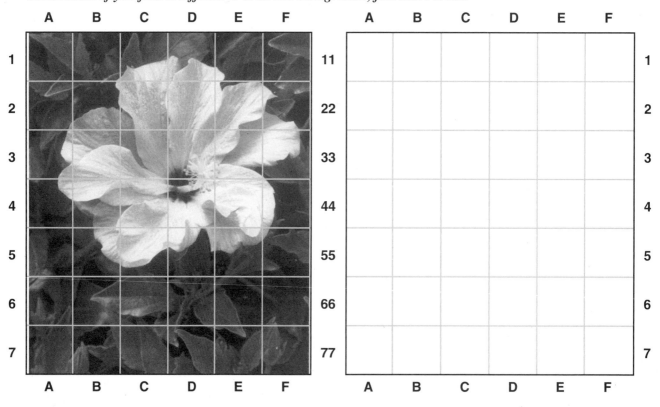

Draw this kitten in the matching gridded box. If you prefer not to use a grid, draw the subject in your sketchbook. If you find it difficult to draw the background, just leave it out.

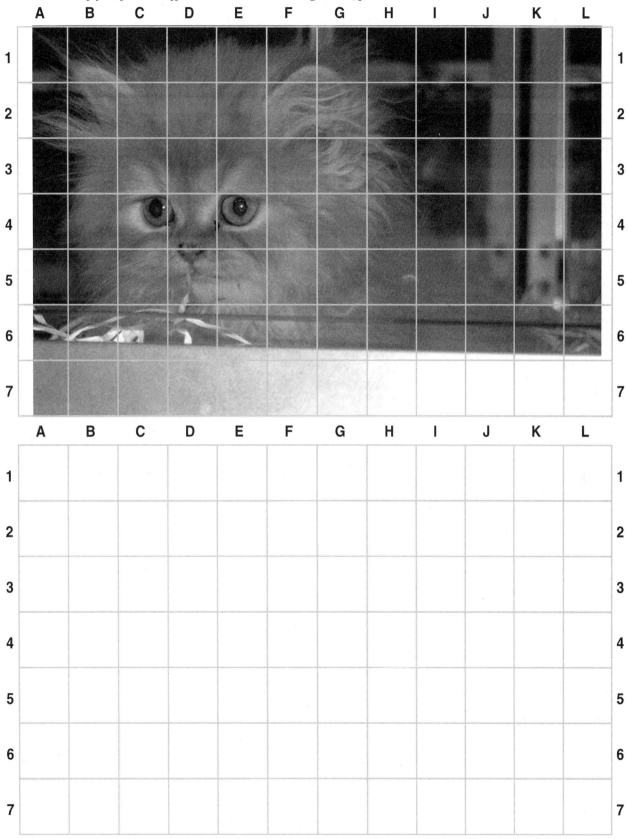

Draw this owl in the matching gridded box. If you prefer not to use a grid, draw the subject in your sketchbook. If you find it difficult to draw the background, just leave it out.

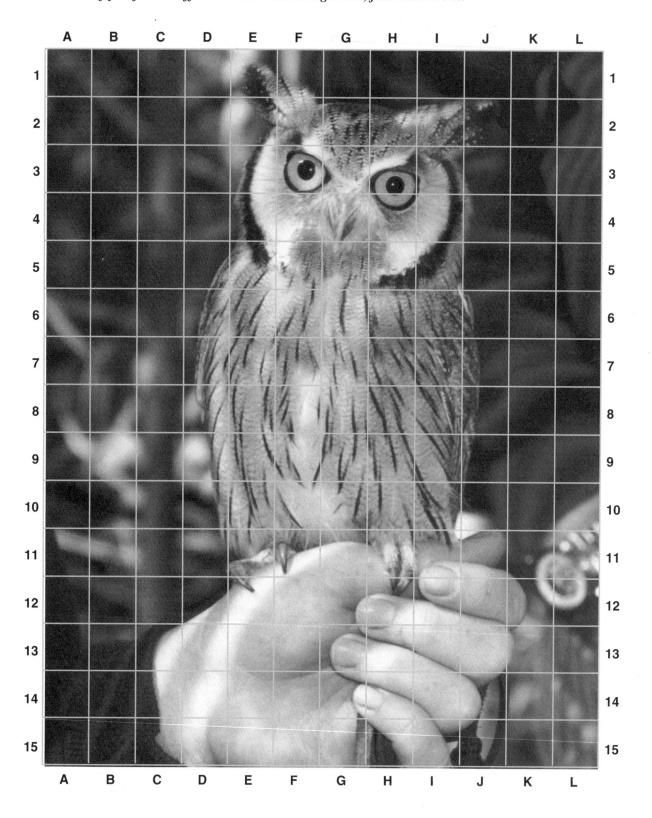

Practice Page

What materials do I need to get started in drawing?

Because I write books, videos, magazine columns and TV shows, I am always reviewing the latest products. I carefully test and update our brochure and website with the most recent high quality materials. I also make research trips to Europe to find new materials… (Aren't I noble? It is the least I can do for you as your personal toy shopper, eh?)

I do not list brand names on my order forms because products are frequently discontinued or updated. We simply carry the top of the line at all times. **CAUTION:** *If you use a lower grade than I'm recommending, you won't get the same results. You will think it is your skills, when it is actually your materials that are limiting you.*

To save you from floundering around trying to figure out what to buy I have grouped my favorite art materials by category. On each list, I simply added new tools at the bottom. Buy whatever you can afford.

1. BASICS: If you are on a very limited budget purchase these essential tools.

2. BEYOND BASICS: If you can afford to spend a bit more, you'll find these additions useful.

3. INDULGE ME: If you have the luxury of buying everything, you will really enjoy adding these tools to your collection, especially the battery operated eraser. This tool is too much fun. Be sure to add the refills – 70 to a box.

> You can order all of my favorite stuff and more on my website
> www.SandraAngelo.com or call Toll Free: 1(888) 327-9278.

Sandra's Favorite™ Supplies for Drawing

Items can be ordered in kits or à la carte.

Prices as of Jan. 2006. For updated prices check our website.

Set One - Basics	Quantity	Price	Total
Goat Hair Dust Brush		8.99	
Portable Pencil Sharpener		23.99	
Sandra's Favorite™ Austrian Graphite Pencils - 12 degrees		15.99	
Kneaded Eraser		1.79	
So You Thought You Couldn't Draw™ 150 pg. workbook		22.99	
		Subtotal	

Set Two - Beyond Basics	Quantity	Price	Total
Goat Hair Dust Brush		8.99	
Portable Pencil Sharpener		23.99	
Sandra's Favorite™ Austrian Graphite Pencils-12 degrees		15.99	
Austrian Woodless Pencils, extender, protector & eraser		19.99	
So You Thought You Couldn't Draw™ 150 pg workbook		22.99	
Pencil Drawing Techniques (8 Books in One!)		19.99	
Sandra's Favorite™ Hardcover Sketchbook		15.99	
Grid Kit – May be Used With all Sandra's Sketchbooks		9.99	
		Subtotal	

Set Three - Indulge Me!	Quantity	Price	Total
Goat Hair Dust Brush		8.99	
Portable Pencil Sharpener		23.99	
Sandra's Favorite™ Austrian Graphite Pencils -12 degrees		15.99	
Austrian Woodless Pencils, extender, protector & eraser		19.99	
So You Thought You Couldn't Draw™ 150 pg. workbook		22.99	
Battery Operated Eraser		57.99	
Battery Operated Eraser Refills		11.99	
Pencil Drawing Techniques (8 Books in One!)		19.99	
Drawing Animals by Norman Adams		18.99	
Sandra's Favorite™ Hardcover Sketchbook		15.99	
Grid Kit – May be Used With all Sandra's Sketchbooks		9.99	
Sandra's Favorite™ Over the shoulder Carrying Case with 6 plastic boxes for pencils, erasers, brush, etc.		39.99	
Set of 5- 9x12 Rigid plastic sleeves to protect drawings		24.99	
Sandra's Favorite™ 11 x 14 Performance Tablet,100% cotton		18.99	
Sandra's Favorite Color Corrected Drawing Lamp		89.99	
		Subtotal	

Order Form

Take PRIVATE ART LESSONS in Your easy Chair with Sandra's DVD/VIDEO ART CLASSES

Quantity	Videos		DVD's
Buy 1	**$29 ea.**		**$39 ea.**
Buy 4	**$22 ea.**		**$25 ea.**
Buy 8 and get 9th FREE	**$19 ea.**		**$22 ea.**
Buy 18 get FREE 32 pg. Colored Pencil Drawing Book	**$16.95 ea.**		**$17.95 ea.**

So You Thought You Couldn't Draw™ Companion DVD's/Videos	Price	Quantity	Total
Drawing Basics			
7 Common Mistakes and How to Correct Them			
The Easy Way to Draw Landscapes, Flowers & Water, plus Water-Soluble Graphite Techniques			
The Easy Way to Draw Animals			
The Easy Way to Draw Faces			
		Subtotal	

Other DVD/Videos by Sandra Angelo	Price	Quantity	Total
Color Theory Made REALLY Easy			
Paint Like Monet in a Day® with Oil Pastels			
Easy Pen & Ink Techniques for Artists and Crafters			
Creating Dynamic Compositions: What do I do with the background?			
		Subtotal	

Colored Pencil DVD/Videos	Price	Quantity	Total
Getting Started with Colored Pencils			
Special Effects with Colored Pencils			
Realistic Colored Pencil Textures			
Time Saving Colored Pencil Techniques			
Building A Nature Sketchbook			
Drawing Your Loved Ones: Pets - Colored Pencil			
Drawing Your Loved Ones: People - Colored Pencil			
Drawing with Colored Pencils on Wood			
Watercolor Pencils, The Portable Medium			
		Subtotal	

Other Books by Sandra Angelo	Price	Quantity	Total
Exploring Colored Pencil - 150 page textbook	27.99		
Colored Pencil Drawing - 32 pages - 7 techniques	8.99		
Create with Colored Pencils on Wood	8.99		
		Subtotal	

Date of Order:	
Your Name:	
Phone:	
Address:	
City:	
State:	Zip:

EMAIL:
Please print legibly… we do all of our communication by e-mail. Use upper and lower case as required. ❏ YES, I would like to receive your free art lessons and newsletters by email. We offer free email art lessons every two weeks. We also use email to notify our students regarding upcoming classes, sales, new books, workshops, etc.

Paid By: ❏ Check ❏ Cash ❏ VISA ❏ M/C

Card #:

Expiration Date:

Signature:

Order Total:	
CA Sales Tax 7.75%	
Shipping and Handling - Add 10%	
Total Due	

Discover Art with Sandra Angelo, Inc. ● San Diego, CA

Order on Website @ www.SandraAngelo.com or by Phone:
San Diego County - (858) 578-6005 Outside SDC - TOLL FREE: (888) 327-9278
Email: Info@DiscoverArtWithSandra.com or BMCV1@aol.com